expecting style

LAUREN SARA

PHOTOGRAPHY BY
MICHEL ARNAUD

BULFINCH PRESS
AOL Time Warner Book Group
BOSTON · NEW YORK · LONDON

OPPOSITE

My mother, pregnant with me and my twin sister, Beth, as a maid-of-honor, Philadelphia, 1962.

FIRST EDITION

Library of Congress Cataloging-in-Publication Data

Sara, Lauren.
 Expecting Style / Lauren Sara—1st ed.
 p. cm.
 Includes index.
 ISBN 0-8212-2840-4
 1. Maternity clothes. I. Title.

TT547.S37 2003
646.4'7—dc21 2003043721

Bulfinch Press is a division of AOL Time Warner Book Group.

Design by Joel Avirom, Jason Snyder, and Meghan Day Healey

Printed in Singapore

To my mom, Toba,
who supported my design aspirations
by being my most inspiring muse,
and to my children, Henry and William,
the loves of my life.

contents

credits

Thank you to the following for their gracious coordination, cooperation, and wonderful services: Liza Elliot, Expecting Models, Ford Modeling Agency, WhiteSpace Studios, Jont, Joe Ianniti, Samantha Schoengold, Jay V. del Rosario, Kristen Mulvihill, Caroline Colston, Gianna Cosentino, Sarah Laskow, Fay Koplovitz, Ellice Goldstein, and Chelsea Raffellini.

And finally, thank you to the following companies, whose fashions adorn the beautiful models: Adidas, Ben Amun, Andrew Marc, Arlotta Cashmere, Athleta, Autumn Cashmere, B&J Fabric, Birkenstock, Charles David, Cole Haan, Echo, Elie Tahari, Ellen Tracy, Gap, Gucci, Helen Kaminski, Hugo Boss, Isaac, Kenneth J. Lane, Lambertson Truex, Lacosta, Land's End, Liz Claiborne, Longchamp, Magda Schoni, Max Mara, Michelle K, Nine West, Old Navy, Olive & Bette's, Oliver Peoples, Perry Ellis, Robert Clergerie, Roberta Chiarella, Stuart Weitzman, Suzie Rotter, Swarvorski, TSE, Takashimaya NYC, Taryn Rose, Theory, Votre Nom, Wolford, YSL.

acknowledgments

I am indebted to Mary Hoffmaster and Melissa de la Cruz for their time, talent, dedication, patience, focus, and fortitude. Without them, this book would not exist.

My deepest gratitude to Jill Cohen, my publisher, and Kristen Schilo, my editor at Bulfinch; Claudia Cross, my agent; Sarah Hall and Haasan Morse, my publicists; Joel Avirom, the art director; and Michel Arnaud, the photographer who made this book a reality, and whose enthusiasm and creativity elevated my ideas to the next level.

I would also like to thank my friends, whose love and support have been invaluable: Ellis Wachs, who helped me start my business many years ago and has given his unwavering support ever since; Anna Workman, an incredible friend who has blessed me with the greatest gift in the world; Marjorie Honickman and Marsha Perelman, whose love and commitment to our friendship are a guiding force of my life that is with me every day; the entire Cozen family, for helping and guiding me through a challenging time; Jim McFadden and Joanne Hueber, whose hard work, patience, and flexibility have been wonderful.

For the moms (and dad) who lent their beauty and their stories to these pages, my deepest thanks to you and your babies: Birgitte Jensen and Amelie Sultan, Julie Marques and Amelia Moran, Mel Dixon and Eve Alexandra Davis, Olivier DeCoop, Leslie Wayne and Ethan DeCoop, Natalie Chablat and Gai Chablat-Yates, Jennifer Lisimachio and Noah Lisimachio, Diana Roy and Jesse Roy, Michelle Gontier and Ben Nakhuda, Melissa Sexter and Dylan Alex Sexter, Lynn Scott and Mia Frances Scott, Jennifer Brandt and Zachary Marshall Hassett, Ibi Aanu Zoboi and Abadai Djifa Zoboi, Renee Parli-Malkus and Elijah Maxwell Malkus, Michelle Shih and Fiona Xiao-ming Glass, Renee Tobin and Rory Patterson Tobin, Sarah Hall and Esmé Scarlett Zohn, Christina Greeven Cuomo and Isabella Cuomo, Amanda Grove Holmén and Grey August Holmén, Amy O'Shea Knauf and Reagan Shea Knauf, Jennifer Esposito and Luke James Esposito.

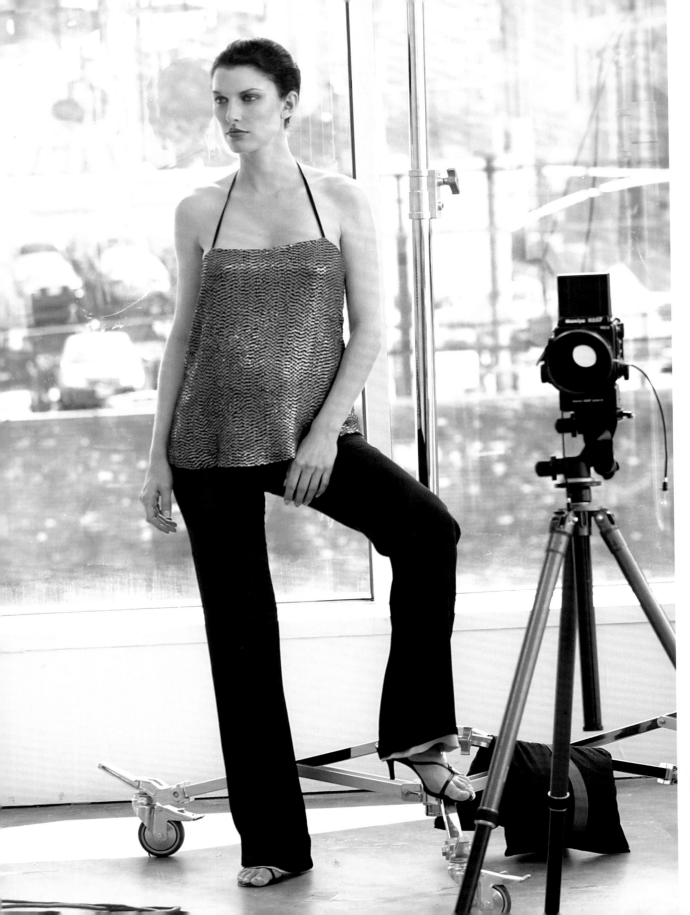

"A woman's sense of style does not change just because her shape does."

introduction

Today's pregnant woman has a developed sense of style. Her method of dressing is personal and refined. But pregnancy is unexplored territory for first-time mothers-to-be, and there is no need to wear a Peter Pan–collar smock top and orange leggings. There is more out there than sack dresses and juvenile prints. You do not need to dress like a sofa just because you are pregnant. Even the most sophisticated, fashion-forward woman needs a little help putting together a great maternity wardrobe.

The image of pregnancy is no longer that of a housewife who stays home while her husband goes to work. More and more women are opting to get pregnant once they have already established themselves in their careers—whether they are twenty-two or forty-two. Today's expecting woman is one who is fully invested in her professional life and who is about to include pregnancy and child rearing in her already busy day. They are women who want to incorporate their growing shape into their already fully formed lifestyles.

After the elation, there is a certain kind of panic that sets in once a woman discovers she is pregnant—especially when it comes to her wardrobe. Many women think that being pregnant means they have to forgo fashion and give up their favorite clothes. You are not interested in shopping for maternity clothes, because you want what you have always worn—the comforting and familiar. But there is nothing to worry about. With sound organization and a keen eye for detail and quality, you will not have to give up anything

and you will be able to maintain your level of polish and sophistication, because with how-to tips, shopping strategies, and tricks from the fashion industry, you can keep your style consistent throughout the whole nine months.

do not panic

We have all been there. You are six months pregnant and next Friday night you are getting together with friends from college that you have not seen in years. As sophisticated women, we do not want to admit that our clothes are important to us. But we get nervous nonetheless—because we want to look good, even if we do have a tummy bulge.

At this point in your life, you have probably mastered your style and developed a fail-safe formula—whether you follow the trends or stick to a similar palette from season to season. But pregnancy throws your fashion sense for a loop, and suddenly you are back to basics. But you can morph your style. For instance, if your pre-pregnancy "uniform" consisted of Lycra T-shirts and hipster khakis, your pregnancy uniform can be a drawstring khaki skirt and a matte jersey tank top. Your fashion vocabulary does not have to change as your proportions do—you just have to make a translation.

first steps

Instead of fretting, fight your anxiety by cleaning your closet. Say good-bye to all your tight-fitting little dresses, waistbanded suits, and skinny trousers. Put plastic over them, or better yet, move them to a spare closet to make room for your new wardrobe. You are not going to be able to wear them until next season, or even next year. Save those summer dresses for next summer. But do not worry, they will return to your closet soon enough.

Most of us have a preconceived idea of what maternity dressing will entail—but forget all those assumptions! You think that "maternity style" is a paradox, but you are wrong. The reality is, you have a lot more in your closet that can take you through almost all nine

months. And by buying intelligently and conservatively, you will be able to put together a highly adaptable, stylish, and comfortable maternity wardrobe. Understand that acquiring this wardrobe is a slow process—a lot of pregnant women make the mistake of shopping too early and buying too many clothes they end up not wearing or needing.

Instead, build your maternity closet slowly—bear in mind that your shape and size are ever changing. You will have to forgo the notion and familiarity of having a consistent body shape and accept the fact that your body is transforming daily. You do not know what the future will bring, and every woman's body changes at a different rate. Some women's bra size does not change; some notice incremental changes—from a C to a D cup, for instance—and other women go straight from an A to a D! There is no similarity in pregnancy. Even your second pregnancy may differ wildly from your first or your third. You may get bigger faster, or not—nobody can predict what will happen over the course of nine months. For instance, your legs may be your best feature in the third month, but not in the seventh.

The best way to prepare is to think of pregnancy as a slow-moving escalator. At no one time are you where you were two days ago.

1.
from here to
maternity

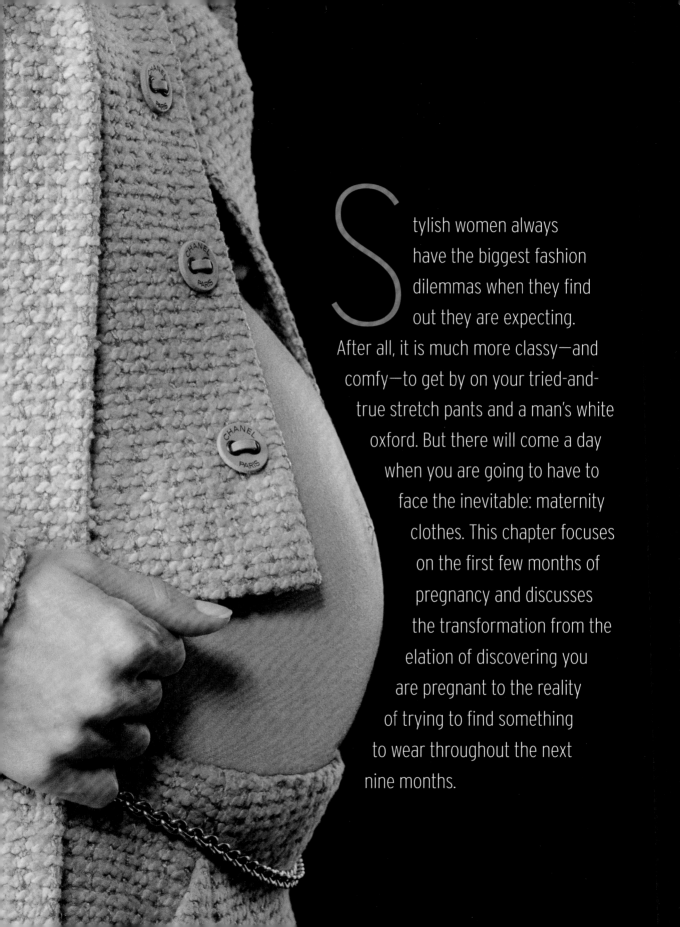

Stylish women always have the biggest fashion dilemmas when they find out they are expecting. After all, it is much more classy—and comfy—to get by on your tried-and-true stretch pants and a man's white oxford. But there will come a day when you are going to have to face the inevitable: maternity clothes. This chapter focuses on the first few months of pregnancy and discusses the transformation from the elation of discovering you are pregnant to the reality of trying to find something to wear throughout the next nine months.

style denial

otherwise known as "I will not need maternity clothes and heaven forbid I be seen in that."

Denial is strongest in the first months of pregnancy, when you are deliriously happy with the news. Your body has changed very slightly. You think, "Oh, this is really cute." Your waistline has changed minimally, your chest is a little bigger, and your male partner thinks you are the sexiest mama alive. You are thinking, "This is it, I can handle it." Well . . . you are delusional!

While you are excited and willing to accept the first changes you recognize in your body, you are under the mistaken assumption that you will just get a "little bigger" in the next few months. Your bra size has gone up, but you are even starting to think, "I will not have to give up my jeans! I will just give my leather pants to my fabulous tailor to accommodate my belly!" Whether you are a size-two, angora-wearing fashion maven or a no-nonsense cardigan-and-sensible-shoes aficionado, you are kidding yourself by believing you will not need maternity clothes.

Denial means different things to different women. You might think putting your waistband lower is going to help. It might for a while, and then one day you just look silly. Those in the strongest grip of denial are women who believe they are the special ones who will not need maternity clothes. They forget that their chests have become substantial and that viewed from behind, they may look a little like linebackers.

Emotions during pregnancy run the gamut—the full spectrum, from suspension of disbelief until the breakdown of denial. It happens to all women, some more gracefully than others. Everybody thinks she can "trick" the baby into fitting into something. Denial lasts until the day you realize that it is not going to work anymore. No more tricks, no more

kidding yourself. The process is difficult for everyone, and we all like consistency and familiarity, no matter what our budget is. We do not like the new and uncharted fashion waters. We become pregnant because we want babies—we are interested in the goal, not the process that gets us there.

on-the-street interviews: DENIAL

"At my eighth month, I was still wearing a lot of my regular clothes! I was in *huge* denial—I wore everything too small. It is amazing how much things stretch. I wore these cheap drawstring skirts I had for as long as I could—and I am a designer-label girl!"

—Graduate student, New York City

"When I first got pregnant, I definitely went through a bit of denial. I swore I wouldn't buy maternity wear. I just bought the next size up and up. Then when my alteration bills began to skyrocket above the purchase prices, I wore elastic-waist skirts and hid under big sweaters. I became a fanatic for anything that fit under my belly."

—OB-GYN intern, Cincinnati

"I woke up one day and none of my clothes fit! I am usually a size six, and I just popped! My husband accompanied me to the maternity boutiques. He could not believe what he saw! The store was divided by color—the wall of purple, the wall of chartreuse, the wall of fuchsia. He turned to me and said, 'I can't! I won't let you!' I was desperate to buy something, but he was pulling me out of these stores."

—Business executive, Denver

Here are a few items that will help you tweak your clothes when you find they just do not quite come together like they used to:

- Rubber bands. Loop a rubber band into a figure eight around your trouser button and safety-pin it to the other side.

- Safety pins. Hook safety pins together to make a bridge from button to buttonhole.

- Double-sided tape. Tape is useful for quick little tucks and folds, and it keeps clothes from looking bulgy.

- Velcro. You can slash and insert Velcro into side seams, and safety-pin it to the front of your pants. With Velcro, you can let out your pants zippers.

- Needle and thread. A must-have. Don't leave home without them.

- Pieces of elastic. Keep them on hand to replace your drawstring with a customized measurement.

- Mitten clips. Use these to make an Empire line to your waist by pulling in excess fabric at the back. They fix the gap-in-the-back problem, and create an inverted pleat in the midsection of your back.

- Scissors. Use them to make side slits in T-shirts.

- Adhesive bandages. You always wondered what the round one was good for— you'll know the answer when the question "pops" up.

HOW TO MODIFY YOUR QUICKLY SHRINKING WARDROBE

- Leave jackets open. You can still wear that perfect jacket you love—just let it hang open from your belly on down.

- Wear shirts as tunics. Do not tuck in your shirts; instead, wear them out and long. This might be the time to make a trip to Brooks Brothers and get some really fabulous cotton button-down shirts: you are going to need one or two freshly pressed shirts that you feel good about.

- Layer. Wear a tight-fitting tank top under a shirt so you do not look so bare. Look at pieces that used to be worn separately and use them as layering pieces. For instance, wear a tank top underneath a button-down shirt with a favorite jacket. Wear the shirt unbuttoned and the jacket open.

- Create an Empire waistline. Leave all buttons below your chest open.

- Wear your twinset cardigans tied around your shoulders instead of on your body. You can still keep a polished look without sacrificing your style.

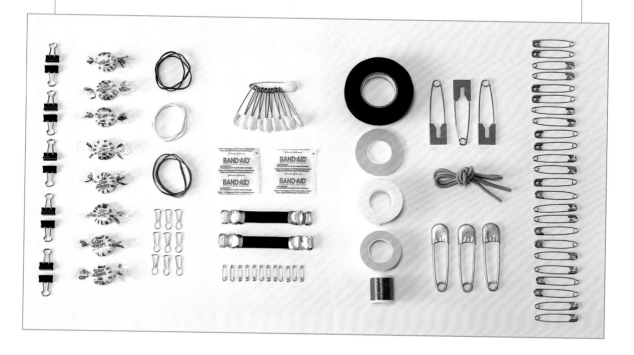

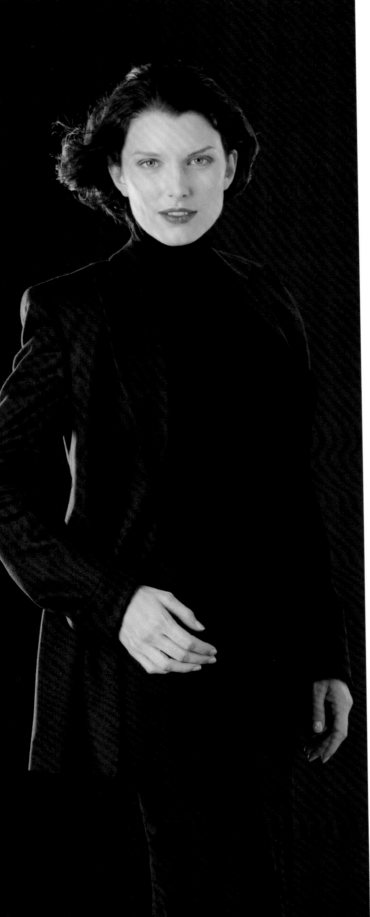

expanding
your options
adapt your wardrobe
to your growing shape

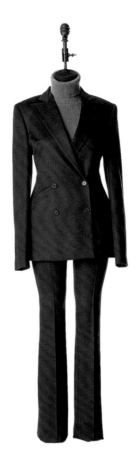

ABOVE

Your "I mean business" pantsuit was a favorite
pre-pregnancy. Don't despair—it can remain a
favorite during pregnancy as well.

LEFT

You won't be able to use the pants, but the
double-breasted jacket will come in handy. Even
if it no longer buttons, wear it open over a skirt
and turtleneck. Keep the corporate edge. Don't
miss a beat and don't spend a fortune.

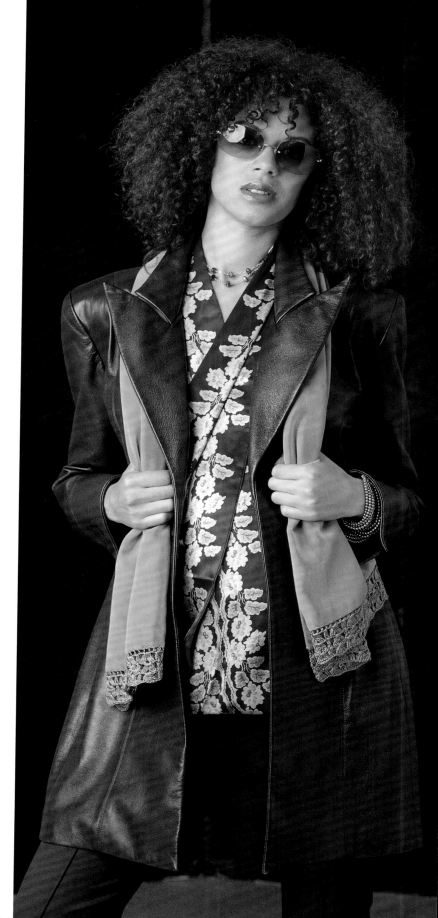

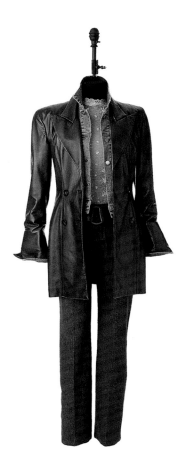

ABOVE

The beautiful leather jacket you bought on your trip to Italy can still be a part of your new wardrobe.

RIGHT

Wear it open and mix it up by layering it over a striking tunic and a colorful scarf. Or layer it less—treat it like an open cardigan jacket.

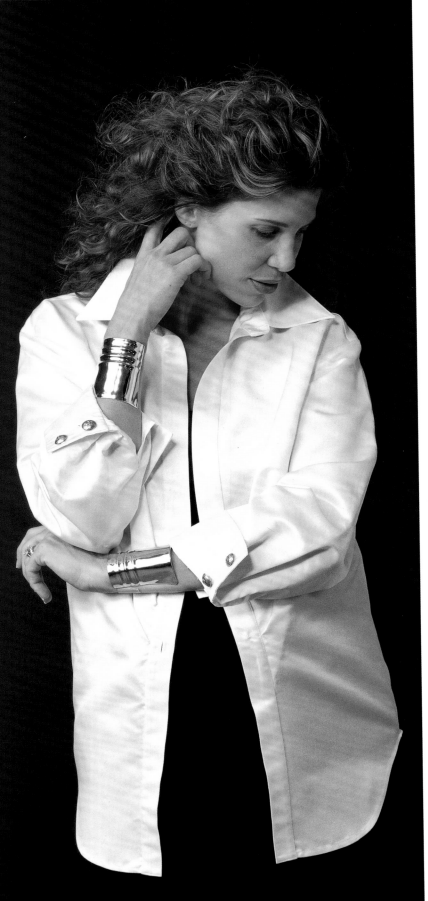

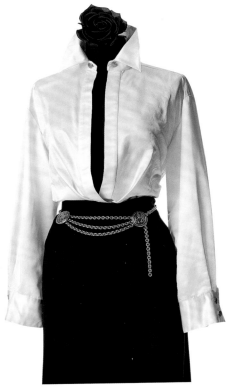

ABOVE
Here is your important formal white satin gold-cuffed evening shirt that you used to wear with your high-waisted black skirt and your Chanel-like chain belt.

LEFT
During pregnancy, wear the shirt open and layer it over a bare tank top, pairing it with slimming bootlegged pants. The important features of the shirt—collar, cuffs, fabric, and shine—are still flattering and available to you.

countdown to desperation day
(OTHERWISE KNOWN AS THE MONDAY MORNING DILEMMA)

You have been lounging all weekend in a man's oversized shirt and your most comfortable sweatpants, but now you have to go to work. There are three stages of denial until desperation kicks in.

- You are still working with what you have. Everything fits and still fits perfectly. "My pregnancy is well hidden," you think smugly. "I can do this. I am not going to get that big. I am just a little curvy right now."

- "Okay, my favorite jeans do not fit anymore, but—aha—here is a cute little rubber band. If I can just put it there . . . and then loop through here—yes!! It works." This is the stage when you have little secrets holding up your clothes, just like the pin you used to hem your skirt at the conference. This is when you discover the myriad uses of a paper clip.

- The designer jeans are well in your past, but you may still have that smock you never wear because it makes you look, well, fat. You realize you have clothes that can cover your body—but do you really want to show up to work wearing a smock? You are emotionally attached to your suits and suddenly you are saying good-bye to Saks and hello to sacks. It has taken you years to get your formula down—no, you are not one of those just-black-pants-and-black-turtleneck people, but you have your outfits. Now that you are pregnant, however, the formula does not work anymore. Your clothes have abandoned you. You have hit . . .

desperation day

Welcome to Desperation Day. This is the day when the elastic splits on your favorite Lycra pants, when the zipper to your low-waisted trousers will not close, when the safety pin on your Banana Republic khakis pops. The day when denial ends and desperation begins.

You have ransacked everything in your closet. Today of all days, why does *nothing* fit? It fit yesterday—it might fit tomorrow—you cannot believe this is happening to you! Your closet is a heap of clothes on the floor. Oh, wait, maybe this Gap shirt will work, even if I wear it only to the gym. Or what about trying to approximate a soccer-mom-sensible look today? *But wait,* you realize, *I am a lawyer and I cannot go to work looking as if I should pick my sons up from practice.*

the rules of the game

A stylish woman wishes to remain so throughout her pregnancy. There is no need to go from style maven to fashion victim because you do not know what to wear. Here are some tips on how to limit your spending and put together creative non-maternity-style looks that are proven lifesavers. Even a self-proclaimed fashionista may need a little help.

Do not buy too many items in the first month—i.e., do not shop too soon! Every woman, after her first pregnancy test, is so excited or horrified that she immediately steps inside a maternity store. The tendency to buy just so you can shop is a legitimate feeling, but let it pass. Shopping too soon is the most common mistake. Impulsive shopping, without really assessing your situation or what you can wear, is never a good idea. There is no reason to buy clothes all at one time—plan what you need. On a weekly basis re-evaluate your body and your needs. You want to amend slowly. Do not try to buy a whole new wardrobe.

Whether you live by your BlackBerry schedule, post-it notes, or calendar—figure out what you need for big events. Look at your calendar for what is upcoming and consider making a personal time line. Ask yourself, "What can I wear? What feels comfortable? What do I need? How can I supplement what I already have?"

Good organization and prior planning during pregnancy can minimize the emotional distress of adjusting to a rapidly and radically changing body.

investment strategy

Every woman has an inventory of clothes in her closet: the navy peacoat bought fifteen years ago that still works with any of your trousers, the fancy black dress you pull out every other year to wear to a charity ball, the knee-high boots that have seen you through every winter. But as a pregnant woman, you suddenly have no inventory. You do not want to spend a king's ransom on maternity clothes, but you will wear the same key pieces over and over again because there is suddenly no depth to your wardrobe. Unlike regular clothes, maternity clothes have a more constant rotation . . . with a lot of stress on every seam, collar, and cuff. You will be wearing those four or five outfits every week for the next several months, and they need to hold up and look good even after constant wear. Spend your money wisely and always look for quality rather than quantity.

FUTURE PERFECT

Here are some tips on how to prepare for the future:

- If you find something you love, buy it in one or two maternity sizes bigger than the size you are now when you see it. If you really like it, it will take you through your entire pregnancy. The chances of finding something you love in your future size and the right color are slim.

- Buy two of each kind of garment that you need. Your clothes will suffer a lot of wear and tear.

- Stock up on pants. One pair will not take you through your entire pregnancy.

one smart purchase from start to finish
a solid nine-month investment

Sarah is a corporate lawyer with a simple, traditional, and classic style. She favors dark colors, clean lines, and tailored outfits. When she started to notice that her waistbands were feeling a little tight, she wanted to buy a high-quality outfit that would last through her entire pregnancy. Here's how she wears a jacket and dress ensemble set for nine months. At two months, she can button the jacket and pair it with her high heels for an after-work get-together. At six months, she wears the coat open and with dark tights and loafers for the office, with absolutely no change in her personal style. At nine months, "inner heat" has taken over, and the jacket is no longer necessary, but because she does not want to give up the height she's used to, she wears a pair of sturdy summer wedges. Post-pregnancy, after a quick trip to the tailor, her tank dress becomes a sexy tank top, and her cardigan jacket is made to fit as a short, loose-fitting topper, which she can wear over a pair of navy trousers.

Work all day, dinner at eight.

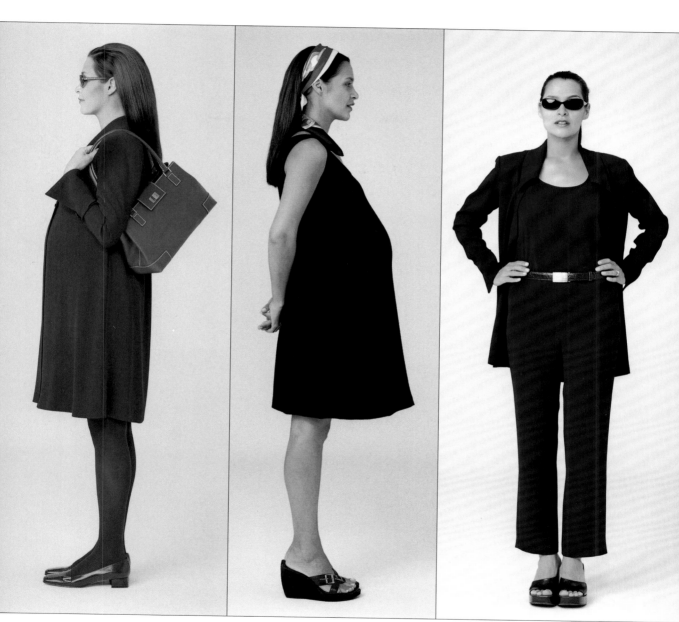

Storm the boardroom without
forgoing an ounce of style.

Beachside chic for the
Hamptons polo match.

Post-pregnant,
ready to face the world.

easy does it
one outfit four ways

Allison is a soccer mom who prefers easy, pull-on
pieces that favor her active lifestyle. She invests in an
outfit that is versatile, seasonless, and comfortable—
a pair of jersey pants, a dark-colored sleeveless tunic,
and a soft cardigan. At five months, she wears the
outfit to meet her husband for his birthday dinner,
pairing it with her own beautiful personal jewelry
to add sentimental touches for a special romantic
evening. A month later, for a charity luncheon, she
throws the cardigan and the tunic over a knee-length
skirt and pairs them with heels for a sophisticated
look. At nine months, she wears the pants and the
tunic with a straw hat for an afternoon garden party.
Post-pregnancy, she picks up her sons from practice
as the hottest mom on the block. She's shortened
the tunic and the cardigan, and tightened the elastic
on her matte jersey pants.

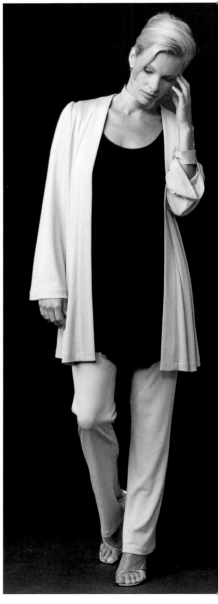

**Polished and put-together
for a romantic dinner.**

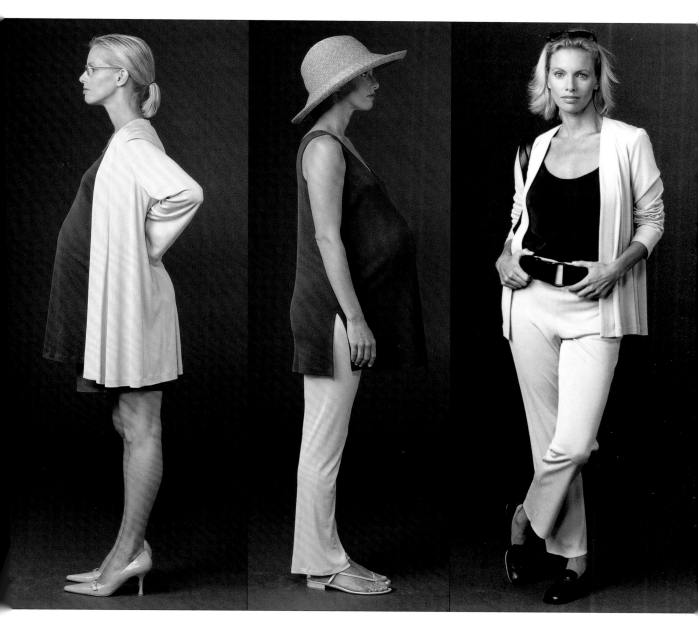

In heels and a skirt
for a ladies' lunch.

Fresh and lovely
for a garden party.

Sexy, svelte, and still
wearing the same outfit.

shopping primer

It is time to move beyond your favorite stretch pants and a man's oxford shirts. After all, oversized Hanes T-shirts do not have to be your new nightgown, and your college sweats do not have to be your at-home staple.

a few things to remember

- Look for sweatshirts that do not have binding at the cuffs and hem—not only is this supremely unflattering but it will make you look like a balloon.

- Beware of shirts and tops with low armholes. You have not gone up in traditional sizing. If you used to be a medium, do not buy larges. Do not be fooled by buying bigger sizes. When you roll up your cuffs and shirtsleeves, you will just look as though you are wearing someone else's clothes. Look for armholes that do not fall down to your waist.

- Steer clear of sweatshirts with kangaroo pockets. They add bulk, which is the last thing you need.

- Look for very good quality fit and fabrics. Maternity clothes take a lot of abuse, and they should hold up well to everyday wear.

- This is not the time to experiment with new colors and fabrics. Wear things you used to wear before you were pregnant.

comfort staples

Here is a list of clothes that will achieve the comfort of your oldest sweatpants. These are your comfort staples—loose, comfortable clothes—so do not buy them fitting tight, as they are what you will wear at home and on weekends.

- **V-NECKED SWEATERS** A hint of cleavage and a lot of comfort.

- **NONELASTIC SWEATPANTS** Choose fabric with stretch and give.

- **T-SHIRTS** Make sure they have a small amount of Lycra.

- **BUTTON-DOWN SHIRTS** Buy ones that actually fit you, not an elephant. Choose vertical stripes or solid colors.

- **OVERALLS** The roomier, the better.

- **BIKE SHORTS** They hold you in and allow you to keep a balanced proportion when you wear them with oversized tops. But, please, make sure they don't fit like sausage casing.

comfort times three

There will come a time when absolutely nothing fits, not even the maternity clothes purchased under duress a few short months ago. The last trimester is the hardest, style-wise, because as you get bigger and bigger, you still need to maintain the bloom on the rose. At six months, most women come to fully appreciate their pregnant shape, thinking, "I am looking great, I can handle it," without realizing that there is yet another blossoming to come. You thought you were big—but you have not seen what big really is.

This is the beginning of the process of organizing your thinking. Getting good use of what you have and adding what you can. Some of the wardrobe staples you can hold on to; you will just incorporate them into your growing shape. There is no need to give them up!

2. wardrobe basics

There is no "correct" way to dress during pregnancy, and this chapter shows you how to make the most of your physical features and personal style. Look at your body and ask yourself, "What are my good points? How can I play them up?" The quality and colors you have always worn can remain the same—but perhaps now that you are pregnant, you are wearing pedal pushers instead of miniskirts.

Your style does not have to change even when your body does. There is no need to reinvent the wheel, nor is it time to experiment with the newest fads. Assess your body's changing shape but do not make the leap to reassessing your personal style. You might need a white tunic instead of a tucked-in white button-down shirt, but do not buy clothes just because they are in the maternity store.

This chapter explores the building blocks of your maternity wardrobe: from the best selection of black pants to the perfect button-down oxford shirt and, of course, the invaluable little black dress.

Color is a personal choice. Whether you gravitate toward deep jewel tones, a neutral palette, or pretty pale pinks, stick to your favorite and most flattering shades at this time of your life. Dress in complementary tones, as opposed to contrasting colors—for example, stone, ivory, and white.

the basic pregnancy wardrobe

A few key pieces every pregnant woman should have in her wardrobe:

- BLACK YOGA PANTS You will wear them even after you have given birth.

- JEANS You know you cannot live without your Levis, Marc by Marc Jacobs, or Seven Jeans. Fortunately, all three labels carry maternity-style denim. But you can also turn your jeans into a maternity pair.

- THE "NEW" LITTLE BLACK DRESS Whereas you may have bought tight-fitting black dresses before you were pregnant, now that you are with child, choose dresses that showcase a beautiful neckline or an interesting sleeve.

- THE STAPLE SHIRT Choose a roomy blouse in many fabrics—cotton, taffeta, wool, and georgette.

- PREGNANCY SHOES Your foot goes up a size. Whether it is Nine West or Robert Clergerie, you can find a slightly watered down version of the shoes you have been wearing.

on-the-street-interviews: YOUR NEW BODY

"When I was pregnant, I stuck to skirts because I was lucky not to retain water and I didn't swell up. When you're pregnant, you have to ask yourself, 'What do I still have to show?' Your legs!"

—Bank teller, Minneapolis

"My breasts became so big that I didn't know what to do with them. Before my pregnancy started showing, people thought I had had a breast augmentation!"

—Saleswoman, Honolulu

"Accentuating your cleavage is fun and a nice reward for everything you are going through. But at six months, my tummy finally caught up and the fun was over! Having cleavage is definitely the most surprising and significant plus in the beginning. I wore tons of low-cut tops, and my husband loved it."

—Newscaster, Dallas

BODY ROAD MAP

Here is how to work with the changes in your figure to make the most of your new physical shape:

- If your legs once seemed a bit big compared with your tiny waist, now they might suit your growing proportions just fine. This may be the first and only time you will look great in leggings.

- Formerly flat? Now might be time to make the most of your new bust.

- If you have always had great shoulders, do not add to them when your belly is getting larger. Shoulder pads do not draw attention away from your growing shape, they just make the whole look oversized and messy.

- If your waist was your best feature, you can still pull off a clean, tailored look even with your expanded waistline by sticking to button-down oxfords and monochromatic outfits.

the basic black pants, A to Z

The first pair of pants you will need and the ones you will wear every day are a basic pair of black pants. It does not matter if they are from Gucci or the Gap. Yoga pants work best, with a free-flowing bottom, or even pants with a zippered bottom. There is no need to buy baggy sweatpants with that horrid elastic band at the ankle. Seek your own waistline level: wear them below or above your belly. But by all means, do not put "a belt on an egg." You might have a Buddha belly in front, but you still have a waist in the back. Do not wear them too low, either—it is not comfortable and looks a little too cute. You still want to look like an adult. Avoid drawstrings at all costs—you do not want to feel like a pup tent.

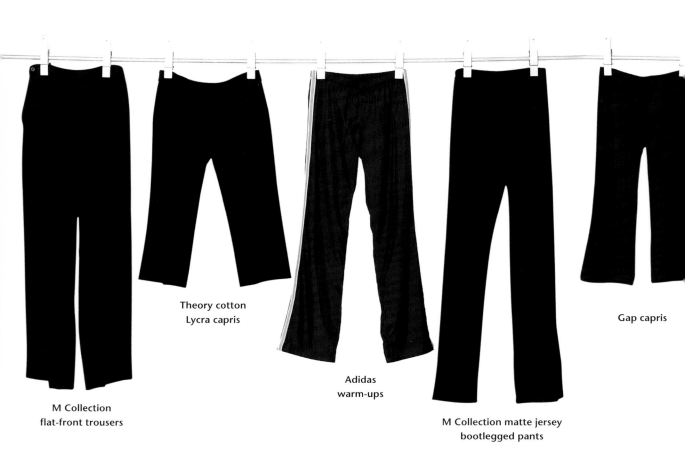

M Collection
flat-front trousers

Theory cotton
Lycra capris

Adidas
warm-ups

M Collection matte jersey
bootlegged pants

Gap capris

going to great lengths: finding your perfect pair of pants is necessary to accommodate your changing shape.

MORE FOR YOUR MONEY

Victoria's Secret "No Waist" yoga pants are our favorite. Who knew? But these $29 pants fit so low on the waist that you don't feel a pinch. You think your pants are falling down, but they aren't. Stock up: you will need them. They will take you from the supermarket to a night on Broadway.

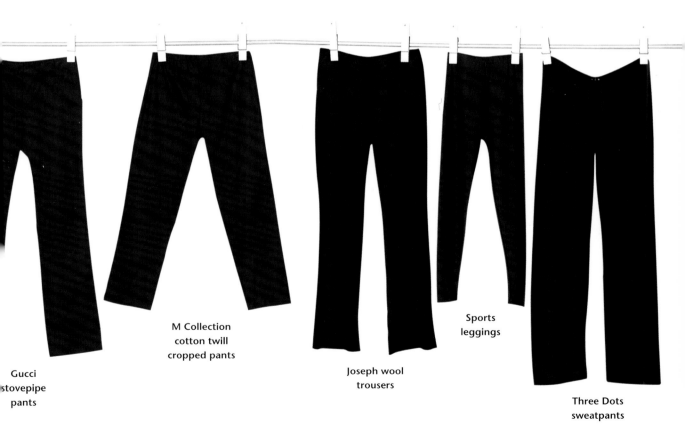

Gucci stovepipe pants

M Collection cotton twill cropped pants

Joseph wool trousers

Sports leggings

Three Dots sweatpants

how to transform your favorite jeans into a maternity pair

Your jeans are your best friends. You wore them to everything—your first date with your husband, your son's baseball practices, or just when you were sitting at home reading on the couch. You don't want to give up wearing them just because you're pregnant. And you don't have to. With a few simple tricks, your favorite pair of denim, corduroy, or even suede and linen jeans can carry you through your entire pregnancy.

Note: This technique can even be used on everything from your houndstooth trousers to beaded evening skirts. Learn it now, so you can utilize it going forward.

step-by-step instructions

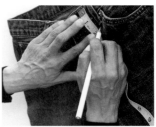

1. Lay your jeans out flat.

2. Mark the side seam of the jeans against the edge of the waistband, angling down to a point approximately 2½" below the center front edge (at the zipper, first photo).

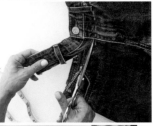

3. Begin cutting along the marked line. You should be cutting off the waistband, below the belt loops (second photo).

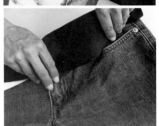

4. Once you have removed the top portion of your jeans, use a safety pin to pin the fly closed. Note: Your new maternity jeans will have an inoperable zipper. The zipper will be stitched closed.

5. At this point, try to pull on the jeans. This exercise (if unsuccessful) will help you determine how much more you need to scoop out of the front.

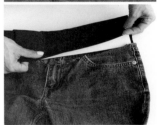

6. Measure the cut edge. Cut a piece of 3" wide elastic, 2½" shorter than the measurement of the cut edge (third photo). (For example, if your new jeans measure 36", cut the elastic to 33½".)

7. Cut a piece of non-itchy Lycra knit fabric (choose any color you like) 7" wide and the same length as the elastic.

8. Sew the two 7" ends of the Lycra fabric together, creating a circle. Place the circle inside the jeans, lining up the edges as you sew the Lycra to the top inside edge of the jeans with a ½" seam allowance, stretching the fabric slightly to fit the circumference (fourth photo).

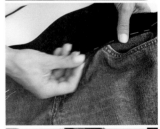

9. Sew the 3" ends of the elastic together, creating a circle. Line up the elastic with the sewn edge. Fold the Lycra fabric over the elastic.

10. Tuck the fabric under the elastic by ½" and pin it, creating a casing for the elastic (fifth photo).

11. Pin the fabric in place along the outside edge. Be careful not to pin the elastic.

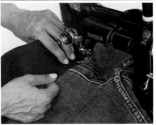

12. Sew the pinned edges as close to the jeans as possible. You should be sewing only the Lycra and the jeans. Be careful not to stitch through the elastic (sixth photo).

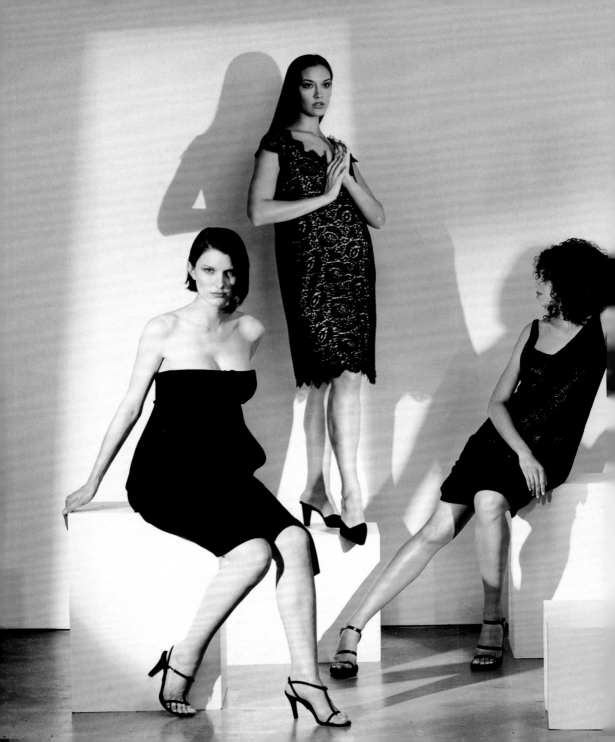

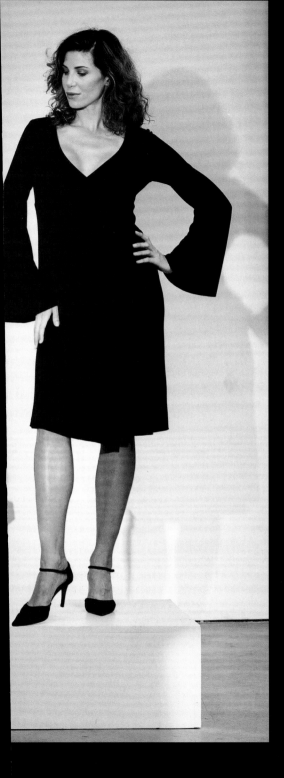

the "new" little black dress

From day into evening, from dinners to meetings to concerts, luncheons, weddings, baby showers, holiday gatherings, or even just because, the "new" little black dress will be the cornerstone of your maternity wardrobe. You may not believe you'll need one, but then you will find fifteen occasions to wear it.

Here are a few examples from left to right. A knee-length strapless Empire waist gown is versatile and flattering for all body types. Wear it underneath a jacket in the daytime, then by itself for a black-tie event. It's an easy, comfortable classic. This one is embellished with a cabbage rose for whimsy—add your own accessories to dress it up or down for the occasion. Small-framed women may want to choose a lace swing dress with cap sleeves and scalloped neckline and hem. Petite women look especially good in this dress, as the cap sleeves minimize the shoulders for a delicate look. Shine on with a V-necked beaded swing dress. The fabric is clingy without being skintight and is universally flattering to expecting mothers. Accentuate your new cleavage with a sexy black matte jersey wrap dress with bell sleeves. Celebrate your curves by flaunting your best assets.

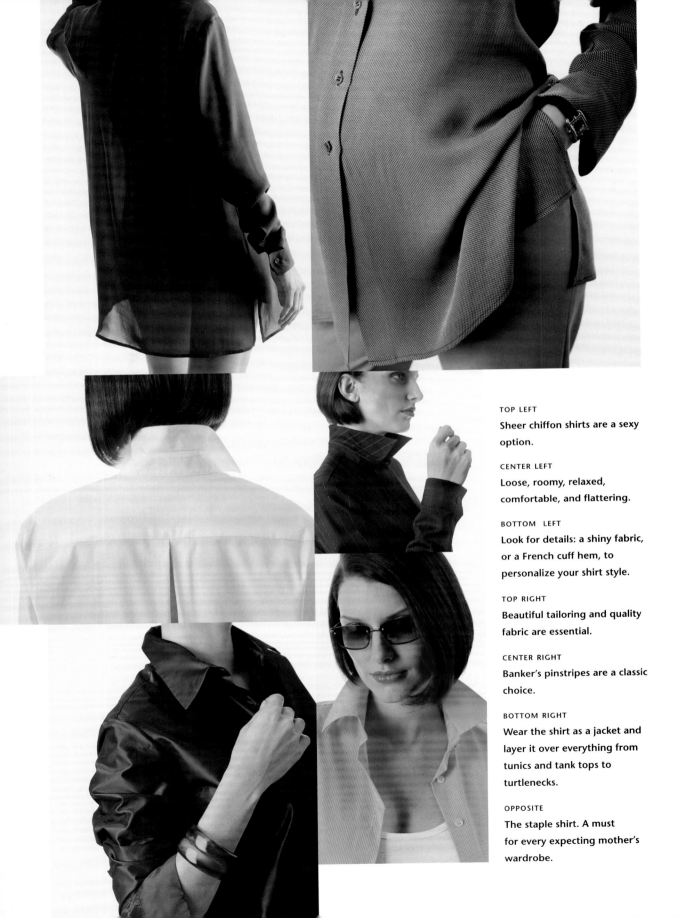

TOP LEFT
Sheer chiffon shirts are a sexy option.

CENTER LEFT
Loose, roomy, relaxed, comfortable, and flattering.

BOTTOM LEFT
Look for details: a shiny fabric, or a French cuff hem, to personalize your shirt style.

TOP RIGHT
Beautiful tailoring and quality fabric are essential.

CENTER RIGHT
Banker's pinstripes are a classic choice.

BOTTOM RIGHT
Wear the shirt as a jacket and layer it over everything from tunics and tank tops to turtlenecks.

OPPOSITE
The staple shirt. A must for every expecting mother's wardrobe.

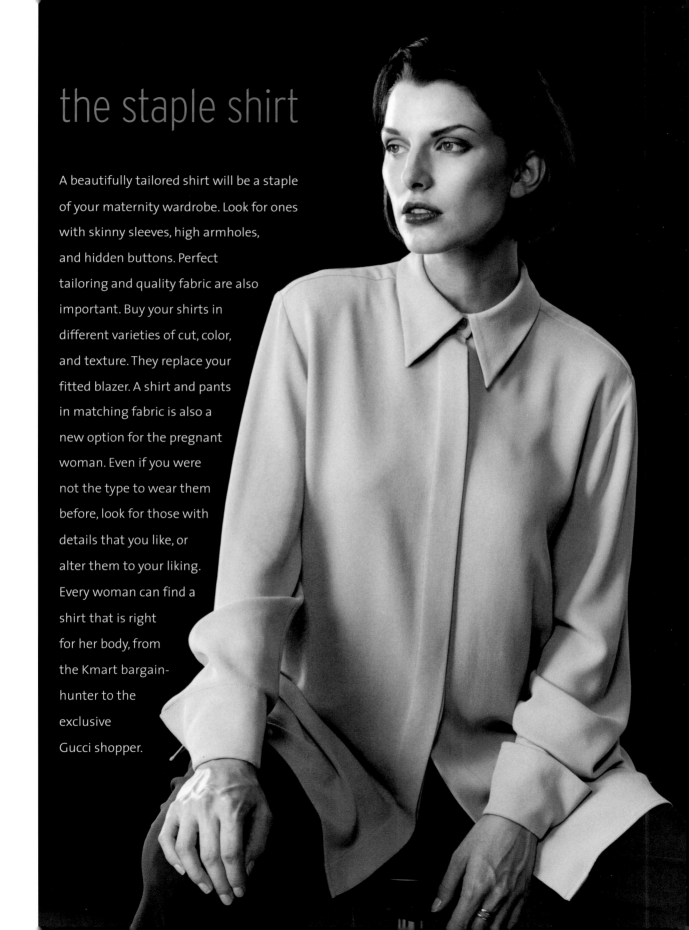

the staple shirt

A beautifully tailored shirt will be a staple of your maternity wardrobe. Look for ones with skinny sleeves, high armholes, and hidden buttons. Perfect tailoring and quality fabric are also important. Buy your shirts in different varieties of cut, color, and texture. They replace your fitted blazer. A shirt and pants in matching fabric is also a new option for the pregnant woman. Even if you were not the type to wear them before, look for those with details that you like, or alter them to your liking. Every woman can find a shirt that is right for her body, from the Kmart bargain-hunter to the exclusive Gucci shopper.

fabric nation

When you are pregnant, look for fabric with a heavy drape to reduce volume and hold a defined shape. Thin knits of quality and density are great choices, as is anything with a bit of Lycra. Cotton poplin and rayon also allow breathing and drapability. Choose fabrics that fall gracefully over your body's new terrain. A fabric that does not wrinkle or crease will suit your new shape better. A seasonless fabric is also essential, as your pregnancy will carry you over at least two seasons. For every season: tropical tissue-weight wools, cotton sateen, silk, silk georgette, silk taffeta, wool gabardine, matte jersey, Lycra knits. Note: Avoid buying fabrics like silk shantung or wool flannel—they do not cross over between seasons.

color theory

Do not feel the need to reinvent your color palette when you are pregnant. If you have never been drawn to bright colors or prints, do not start now. On the other hand, do not shrink your color choices too narrowly. If you do restrict yourself to navy and black, choose clothes with elements of texture and shine to add variety to your wardrobe. Color is the first thing people see and is the defining aspect of one's wardrobe. If you find a fabulous silhouette, color can be the element that keeps your wardrobe looking fresh: keep the same silhouette but vary it by changing the color and fabric. One great shirt in three different colors can give you three different looks.

3.
dressing for daytime

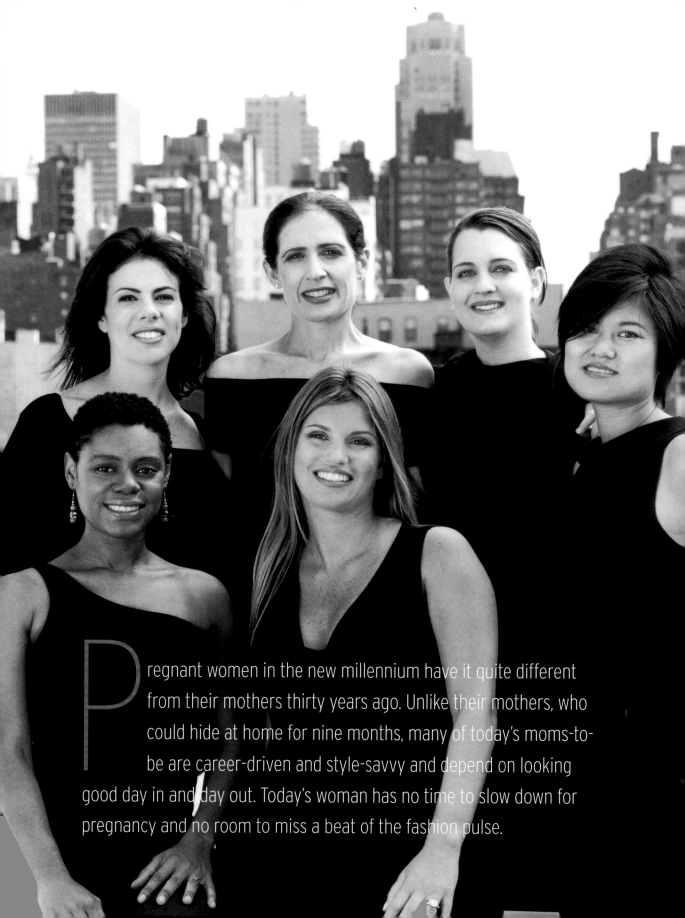

Pregnant women in the new millennium have it quite different from their mothers thirty years ago. Unlike their mothers, who could hide at home for nine months, many of today's moms-to-be are career-driven and style-savvy and depend on looking good day in and day out. Today's woman has no time to slow down for pregnancy and no room to miss a beat of the fashion pulse.

One could argue that the fashion-conscious women of today have it much, much harder. Pregnancy is no longer an excuse or an exception. It does not keep anyone from reading news, litigating cases in court, or teaching a class of students. Women's roles in the workplace are more substantial; therefore pregnant working women are more prevalent than ever. Especially today, women are getting pregnant while they are primarily invested in their careers. They are more concerned about working around their maternity leave— shrinking down the time off while pregnant.

This is a great feat, and a juggling act: nine months pregnant and working! Everyone's personal schedule and time line may vary slightly, but a large percentage of women work right up to their delivery date. Do not believe the old adage that women cannot have it all. Women can have it all. And look good doing it. Growing a family and growing intellectually and professionally are not mutually exclusive.

The women profiled in this chapter did not reinvent themselves. They are not overly fashion-conscious. Consistency and maintenance were their mantras. No fuss. No muss. They did not skip a beat. On the job, on the go—real women share their insights on how they maintained professionalism while pregnant and how they gracefully combined the elements of expectant mom with their working lifestyles.

MOMMY TALK During our photo shoot, here are some snippets of what the moms-to-be said in the waiting room.

"When's your due date?"

"Oh, good—cookies!"

"How many times have you been to the bathroom today?"

"Don't take your shoes off, you'll never get them back on!"

"I am bigger than anyone here!"

"They used to be concave."

"I am starving."

"Who's your doctor?"

"I'm freezing in here!"

"My rings are stuck."

"I'm burning up. Are you crazy?"

"I cannot see my feet!"

"Aren't you hot in that?"

"I feel like a house."

the attorneys

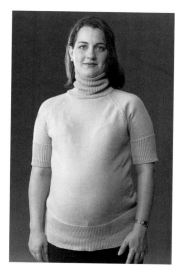

AMY O'SHEA KNAUF "I am a conservative dresser, very preppy. I like khakis and black pants in the fall, and Lilly Pulitzer dresses in the summer. When I became pregnant, I continued to wear my own cardigan sweaters and jackets to work because they still fit for the first five months. During the summer, peasant blouses were very popular, but I did not buy them before I was pregnant, so I was not going to buy them just because I was pregnant. I was a Lilly girl before, and I just bought the Lilly maternity line.

"I kept to tailored separates. I did not want to wear tenty blouses, I wanted my clothes to look polished—fitted, but not skintight. As a lawyer, I was always in suits, but I did not want to invest in a bunch of maternity suits, so I went more casual than I normally do. I wore dresses in the summer with cardigans and sandals, and in the fall I wore tailored trousers with sweater sets or button-downs."

JENNIFER BRANDT "I love clothes. Fashion is very important to me. I own a lot of different outfits and I try never to wear the same thing twice. At the same time, I am not a slave to trends—I follow them, but I have gotten a little better as I have gotten older. I employ more discretion, but I do read a lot of magazines and follow what is new for the season. When I got pregnant, it was distressing—what was I going to wear? At three months, a lot of my clothes did not fit anymore and I was not prepared to shop for maternity clothes. I was in the in-between stage that no one told me about—I had to drag a lot of older things out of my closet. I was not as bad as other women I have seen, who are totally delusional

about not needing maternity clothes. I have sisters who have kids, and they passed things down to me that fit. Before I was pregnant, I had lost weight from the year before, so I had stuff that was roomier—which got me a little bit further.

"Once I started shopping for maternity clothes, I discovered it was a lot better than what I expected. I am constantly in court and I wear dresses and skirts on the conservative side. When I am in the office meeting clients, I wear tailored pants and sweater sets. It is a big law firm, and overall it has a very conservative dress code. Prior to being pregnant, I wore a lot of suits but I could not find any maternity suits that I liked. I was surprised at the wealth of choices for maternity.

"I am trying to keep in style and keep my look constant. People are still complimenting me and my clothes—they come up to me and ask what I am wearing, so I guess I am doing okay. It is really important for me to keep my professional status while pregnant. I was self-conscious all the way until the start of my third trimester. By then I was more focused on having a healthy baby and an easy delivery as well as anxious about how to balance my life."

the yoga instructor

RENEE PARLI "For a while, I was in huge denial about maternity clothes but I finally broke down and bought some maternity jeans. The thing is, you start to push toward maximum density. I mean, I go to sleep, I wake up, and I am bigger! At my eighth month, I had to retire these drawstring skirts I was wearing. It gets hard to breathe.

"I like to wear fitted shirts, and T-shirts with Lycra in them because I think those maternity blouses look just like tents and actually make you look bigger than you really are. Plus they

always have those ridiculous big bows and stuff. I have been living in the whole Indian/hippie look—lots of cotton, embroidered tops, caftans, and silk tunics with embroidery. You can get away with a lot—I found that buying regular clothes just the next size up has been a lot less expensive than getting maternity clothes.

"I started out at a C cup and now I am an E. I have been buying bra minimizers—my chest sticks out so much, I cannot even see my belly because my chest is in the way. My backside got bigger too, and I did not want to accentuate that, so I wore a lot of skirts in the summer. It was hot anyway, so it worked out.

"My advice for pregnant women is that you do not have to shop maternity all the time. Look for quality—it is okay to spend two hundred dollars on a pair of pants because you will wear them every day! Splurge on a few very nice, very well made things with good fabric, as they are worth it. I bought this great maternity tuxedo skirt and it was definitely pricey, but I wear it all the time for fancy affairs.

"As a yoga teacher, I feel it is important to keep up my health and strength and show people that yoga can be good for you, no matter what physical condition you are in. I want to be able to work to my maximum in yoga practice, so I can bring strength and maximum relaxation to my students (a few of them are also pregnant). I can inspire them to try a headstand by demonstrating that I could do it while eight months pregnant!"

the stylist

MELISSA SEXTER "I am a shopaholic to the max. I am not a fashionista, but I am definitely up on fashion trends. I am more of a hippie-bohemian type, not conservative at all. As a personal shopper and stylist, I never have to look corporate. My style has been completely consistent throughout my pregnancy with the way I have always dressed. I am very petite, and most of my pants still fit me in my sixth month. I wear my pants very low, and as long as they go under my stomach, they are fine. I can still wear my low-waisted jeans in my size, and for fall I like the idea of long, low-waisted drawstring skirts. I find it really uncomfortable if anything touches my belly. I also wear a lot of baby-doll tops and Empire tops—they show

the bump, but not in a skintight kind of way. I like to adopt regular fashion into my pregnancy style.

"Anything that is in fashion that I can still wear, I do. Juicy sweatsuits have become my day uniform. They are supercomfortable and amazing, and they are really trendy right now. I cannot wear a fitted jacket or a vest, but I can still wear my flowy tops from Marc Jacobs and Beautiful People. I do not wear blouses, because I feel they make you look big and, well, blousy. I like clothes that are fitted or that are made from very flowing fabrics. I like to mix fabrics, too—to wear silks with corduroy—or layer fabrics and show the bump underneath. I like looking polished. And I am still wearing my high-heeled Jimmy Choos like nobody's business.

The only problem is I broke my pinkie toe! Otherwise, I am all right. I live in the high-heeled Michael Kors wedges. They are so comfortable. I have bought one pair of flats for pregnancy—Chanel ballet slippers.

"I love to wear anything with Lycra. I have no problem showing the bump! But one day I was wearing a pair of jeans, high-heeled sandals, and a Joseph Lycra shirt and I never heard so many catcalls in my life! I was so uncomfortable. I wanted to go home and change! Now I realize that if I am going to show the bump, it is not going to be in anything skintight and cream. I am not a 'sexy' show-off type, I like to look comfortable. I am a turtleneck girl. I thought I looked kind of prissy and nice, but apparently men thought otherwise."

the magazine editor

MICHELLE SHIH "While I tried to keep my style consistent, I noticed that I changed in some ways. As a magazine editor, I could wear whatever I want, but I mostly stuck to basic black. I did find when I was pregnant that I was experimenting more with color. During my pregnancy, I wanted to wear my normal clothes for as long as I could. I wore my pants unbuttoned for months and months, and I ruined so many pairs. I borrowed stuff from my sisters-in-law, but the clothes were so ugly! I thought I could just buy regular sizes, so I bought a pair of pants that were drawstring waist and size twelve. But they hit right at the center of my belly and kept slipping down. I was hitching my pants up all the time. I wasted a lot of money.

"I kind of wished I had shopped around more, though. I went to only two stores and got the bare minimum of what I needed. I was pregnant for the whole summer and had nothing once the cold weather hit, and you cannot wear stuff from pre-pregnancy."

the restauranteur

RENEE TOBIN "I am a teacher and a restaurant owner, and both are messy jobs, so I needed a very flexible wardrobe. I wear a lot of black, a lot of pants. I do not race to the top-of-the-line stores, I buy hip staples for the here and now and basically live in jeans and leather pants. I am a conservative dresser, but not work-conservative, just casual. When I became pregnant, I was surprised there

were so many stores that catered to women and different price ranges. If you spend the time looking, you can find a lot of deals!

"I continued to wear clothes I would normally wear—only they were now in maternity sizes. I am addicted to my Levis, so I bought a pair that were extra large and took them to a tailor to make a baby basket in the front. I was really gung-ho to hit the maternity stores, and I did shop too early in excitement. Fortunately, the salespeople were really helpful and guided me through. I would say definitely wait to shop, it saves you money, and things change."

the fashion executive

LYNN SCOTT "I like to look and feel easy and comfortable. I wear very little makeup and I usually tie back my hair and wear casual clothing. For instance, if I am just running errands, I will wear cropped pants, a gingham checked raincoat, flats, and a T-shirt. When I became pregnant, I bought regular T-shirts in large—they are more flattering than the huge maternity tops. When I found something I liked, I would buy it in bulk—I bought these stretch wool bootlegged pants in gray and black and khakis that go with everything, and I bought three pairs of each! I did not buy anything with that horrible pouch in the front—I hate that pouch!

"I guess I am a Kate Spade type of mom: I am preppy, all-American. I bought the same kind of pants as I would wear pre-pregnancy. I bought frayed jeans, cropped jeans, and a patchwork denim skirt. I did not buy maternity clothes until I was in my sixth month. I had a lot of stretchy stuff that I could still wear, and I wear a lot of button-down shirts that are loose. I just did not want to buy huge maternity clothes, so I just wear what I have until I cannot fit into them anymore. I have gotten big—and I was very little to begin with. But I am not little anymore!"

the interior decorator

JENNIFER ESPOSITO "For the first couple of months, everything still fit. I wore my low-rider jeans, bohemian blouses, and Empire waist cap-sleeve tops that were loose-fitting on the bottom to hide the stomach. As I started to show, I really got into the bohemian look—my whole wardrobe became 'boho pregnant.' I loved shopping at ethnic stores. I bought knee-length caftans with slits up the sides. I bought them in solid colors—white, green, pink—and wore them with maternity jeans and designer flip-flops. Maternity jeans get really hot in the summer, though, and my basic pregnancy look consisted of white lacy pants to wear underneath my white caftan. It was white-on-white embroidered with lace. I loved them, and I wore my 'white' outfit with big earrings, bangled bracelets, and lots of beaded necklaces.

"I got bored pretty quickly, though, so I bought more caftans—silk tie-dyed ones, brown with orange splashes. They felt like little bohemian pantsuits. I bought a maternity bathing suit—I am a bikini girl and I did not want to change just because I was pregnant. I was on bed rest for the first three months of my pregnancy. I was really excited to be pregnant and I was really worried about the baby. I wanted to start showing right away. Most people try to hide it, but I wanted my baby to be a reality. It was comforting to start showing, and cute to have a little belly. Now it is really large but I am going with the big belly look, I am not hiding it. I let it all out—my arms and legs are still the same, but people at the beach look at me as though I should probably cover up! I did have a lot of things in my closet that were larger-sized, but the shoulders and sleeves did not fit, so I realized it would have been worthwhile to have bought more maternity clothes.

"It was very important for me to maintain my status while I was pregnant because I was starting my interior decorating business after being a stock trader for eleven years, when I worked all over the globe, including New York, London, and Tokyo. For years I was a power dresser—designer suits and high heels. I stopped working when I got pregnant, and my new look was totally new and fresh. I did not tell anyone I was pregnant for the first three months, so my caftans and my muumuus hid my growing size. I had more and more fun with my new look."

the publicist

SARAH HALL "As the president of my own public relations firm, I am able to dress according to how I feel is appropriate. If I am meeting a funky client, I will dress in a rhinestone T-shirt and expensive trousers. If it is a more sophisticated client, I will wear conservative, clean lines and tailored pieces from Dolce and Gabbana and Calvin Klein. I like to look simple and minimal, so you can imagine my horror the first time I was pregnant and stepped inside a maternity store. That was two years ago, and I was shocked at how out of step they were with real fashion! I became one of those women who say, 'I am not going to need maternity!'

"The waistline is the first to go, and I was popping out and trying to squeeze into regular large sizes—but they are not cut to fit pregnant women. I was fortunate to have met Lauren Sara. One of my clients, the model Vendela, was pregnant at the same time I was, and Lauren had sent her these beautiful clothes. We were amazed at how a designer really answered the problem we had. Vendela needed clothes for her public appearances, while I needed them for my day-to-day work, client meetings, and attending events at night. My lifestyle did not

change. As my pregnancy progressed, it became a real problem for me and was encroaching on my self-esteem. I did not feel as confident and comfortable as I usually do. I felt I did not look my best, so when I discovered Lauren's clothes, I was thrilled.

"Lauren's clothes were not just beautiful, they were functional as well. One of the pieces I really loved was a sleeveless Empire waist dress with a square-cut neck and little detailed buttons. Lauren is the architect of clothes. Lauren explained to me that most pregnant women are concerned with the sway in the back—and she had designed a detailed panel to cover the sway. All I knew is that I looked fantastic while I was wearing it! She reminded me of an old-style Hollywood couturier. She would visit my office with three racks of clothes, and she measured every inseam. She made sure the clothes we selected would fit both my lifestyle and my growing belly. I was pregnant in the summer, but she educated me that most women's pregnancies take them through three seasons. She put my life in order. From the day she got here, at every meeting I took I felt wonderful in what I was wearing.

"The response I got was amazing. It was palpable. When you feel and look that good, people respond to you that way. Everyone said that while I was pregnant, my business would suffer, but my business was thriving. Her clothes gave me the confidence to go out there and keep my pace.

"It was vital for me to keep my level of status while pregnant. My schedule did not slow down because of my pregnancy. As my pregnancy progressed, I became increasingly self-conscious, as my body continually changed. And what looked great during my first trimester was not an option as I grew and the seasons changed twice! Thankfully, after finding Lauren, these fears were put to rest, as I could not find more beautiful clothes than hers. Having said this, I was eager to take new business meetings in my M Collection clothing, since these were the clothes that gave me the confidence to still feel empowered even though my shape had changed. My business clearly benefited from each new meeting I took and each new client I signed."

the newscaster

AMANDA GROVE "I have a varied style: for work I like simple, elegant clothes from Armani, Missoni, and Max Mara, and in my personal life I like relaxed stylish clothes that are a little more funky, from Dolce and Gabbana. I do not like fussy clothes; I prefer simple, tailored, chic. Nothing stuffy or bright. At work I cannot have my clothes, makeup, or hair interfere with my message. I do not want them to distract from the communication, it is not right for television. While I am pregnant, I am trying to keep my style consistent by wearing a lot of monochromatic outfits in all black or brown. It helps to keep me looking sharp. I prefer during pregnancy to wear outfits that are fitted and slender. I am not trying to hide my pregnancy, I am trying to embrace it. I need maternity pants and skirts, but on top, so far, so good. I can wear most of my blazers open and I have four months left. I am trying to wear my clothes as long as I can."

the magazine publisher

CHRISTINA GREEVEN CUOMO "My style varies with my mood and is dependent on my appointments for the day. I stick to earth tones and blacks—I am not big on color in the fall or winter. Most of the time I am very casual since I can wear what I want. I might do a hippie chic. I am not big on suits. I wear a lot of skirts; I like anything low-waisted. I also love wearing sweatsuits—luckily, they are trendy right now. They are so comfortable. I bought them in cashmere, velour, terry cloth. The drawstring waist is great—they are comfy and stylish.

"I am able to wear things that I have not worn in a while. Certainly you can make use of every jacket and coat you own, you just cannot close them. I love clothes with an elastic waist and stretch material or Lycra. I don't cover up my pregnancy—you want to remind people you are pregnant. I tend to wear a lot of sweaters because my body temperature is so sensitive, and so I tend to bundle up."

the writer

IBI AANU ZOBOI "I was pregnant during the summer, when I worked as a teacher at a summer camp. I wore a lot of long sleeveless dresses that were very colorful. When I had the time, I made some clothes of my own. I made the dress I am wearing in this picture. I really enjoy colorful fabrics and putting my own outfits together. I use a lot of African fabric, and some of my clothes are African inspired—I love the colors, shapes, and designs. I like my clothes to tell a story. I also wore a lot of sarongs and T-shirts because I did not like the way my belly looked in shorts. When I was pregnant I wore the same kind of clothes that I did before—mostly long tunics and flowing skirts and peasant tops. I write science fiction and magical realism, and I write children's stories based

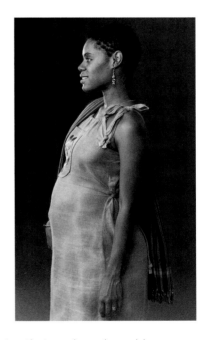

on myths. I have studied a lot of mythology and I retell stories that are based on old legends. How I dress relates to what I write—I am very whimsical, and when I tell fairy tales, I tend to look like a Gypsy.

"I was a little self-conscious about being pregnant. I worked around children, so they had a lot of questions to ask. I tried not to wear anything too formfitting, but then if I wore something loose, I looked too big. So I tried to find a middle ground. I found that skirts that wrapped around my hips and belly were the best option."

from the runway to the family way

here are some designer looks you can adapt to your wardrobe for nine months of high style

Straight from the Seventh Avenue catwalks, here is a collection of maternity pieces that will work for you. No exceptions and no excuses, with these outfits you can continue looking as you always have. Do not focus on the slightly different cut. Look at the fashion. Also, not everything is as it might appear. You can find great maternity wear in discount stores, non-maternity resources, and vintage stores as well as the usual maternity outlets.

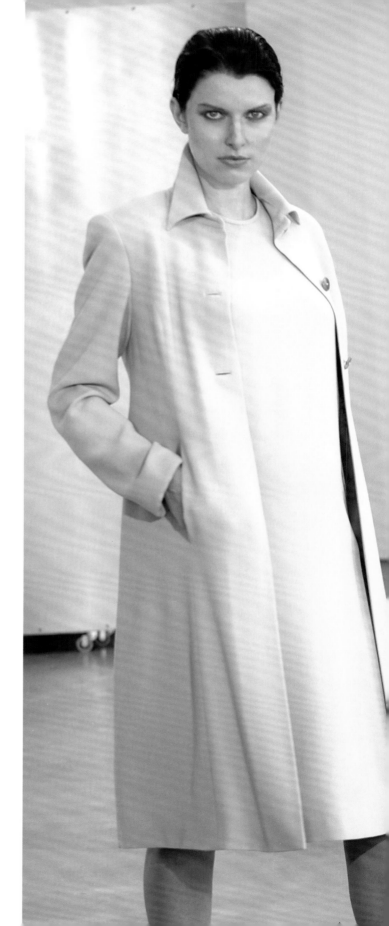

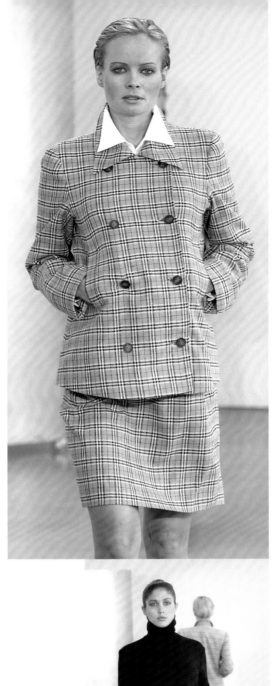

THE NEW SUIT I (OPPOSITE) **If you are a woman who lives in a fitted blazer and skirt suit, meet your new tailored suit. With two great pieces that can be broken apart, this is your corporate-savvy, storm-the-boardroom, go-get-'em-girl outfit. The monochromatic color lengthens the body. Look for seasonless fabrics (here, textured tropical wool). The ice blue color is unexpected, and perfect for spring or fall with a quick change of accessories.**

PLAID TIDINGS (LEFT) **A classic peacoat with a slim elastic-waist skirt can work together or separately. The skirt is great with an overshirt, and the jacket is the perfect topper for jeans. This subtle plaid is best if you crave a bit of texture and pattern. A conservative, traditional plaid is the best way to get a bit of color into your wardrobe.**

A-LINE TURTLENECK DRESS (BELOW LEFT) **Think of it as your favorite turtleneck, cut a little longer. It has the ease of a sweatshirt, and the weight and density of the knit drapes well over a pregnant stomach.**

CLASSIC SHIRTDRESS (BELOW) **A tropical wool shirtdress in navy blue pinstripe looks polished enough to stand on its own. It will be the dress you reach for all the time. No thought necessary—pull it on and go.**

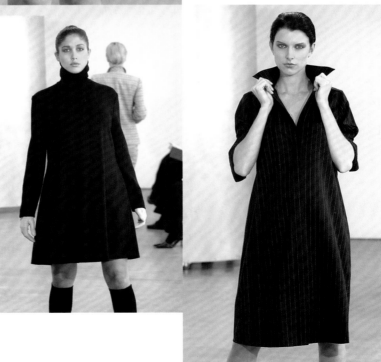

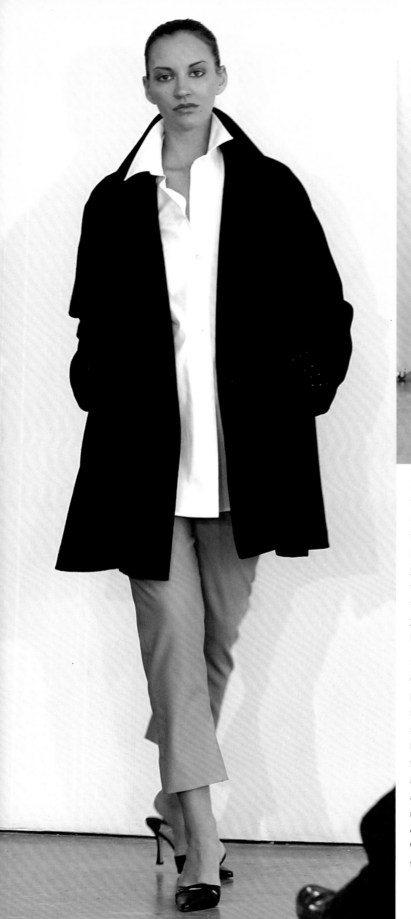

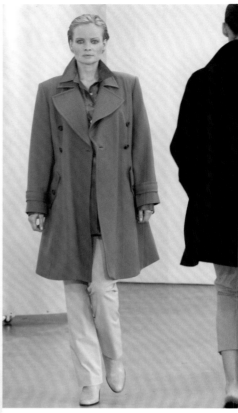

PLAYING WITH PROPORTION (LEFT)

When you are pregnant, look for coats with no closure. This tailored wrap is swingy but not tentlike and is outfitted with deep pockets. The length is great for walking. This jacket will take you through the bulk of your pregnancy. Pair it with cropped khaki pants and delicate mules or flats. This outfit has the three perfect colors for your closet—black, white, and stone—which can be worn in multiple variations.

BOGEY'S BEST (ABOVE) One of the most

enduring silhouettes is a trench coat—a perfect, practical buy that you can find in a non-maternity department. Take off the belt and save it for post-pregnancy. The trench's double-breasted lapel and wide collars will take you through every stage of your pregnancy. Buy it in a slate blue as a wonderful accent to your black and navy staples. Stovepipe pants make the most of the thinnest part of your leg and elongate the look by balancing out proportions. Wear them with anything from a lug-sole shoe to a square-toed boot.

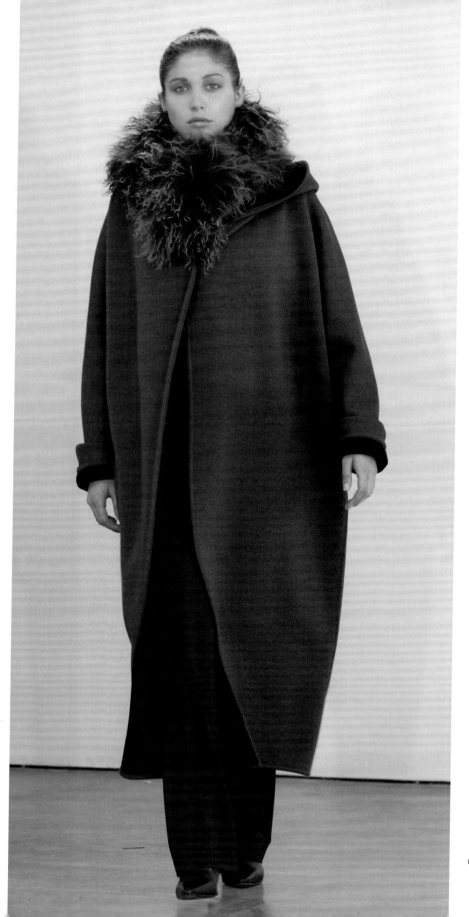

COCOON COAT Cocoon yourself and your baby in a luxurious blanket coat that is fabulous for travel. It works as a coat—and a blanket! This unconstructed coat is the best thing to throw over more-tailored clothes. It spans the work week and the weekend, from daytime meetings to evenings in the city. It is fully reversible, making it even more versatile. Coats with no closure might be new to you, but do not rule them out. They allow for growth during all nine months.

dressing for daytime 69

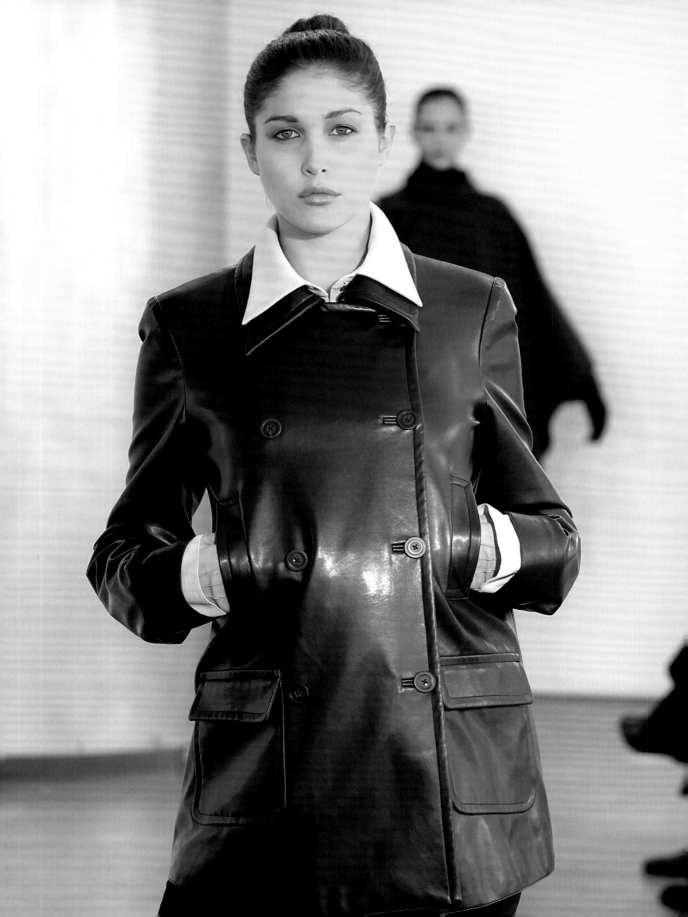

LONDON CALLING (OPPOSITE)

This rubber coat is a bit of a splurge, but what a great piece to make you feel that you are in style. It's an outrageous purchase, so keep the color practical. Here, it is shown in architect gray with skinny gray pants. The rubber is waterproof, so it doubles as a raincoat. Think of it as rainy day leather for foggy days.

THE WINTER PONCHO (RIGHT)

This is an attention-getting, dramatic entrance-maker. Play the diva with drastic new proportions that exaggerate your shape. Invest in a unique top, but keep the color consistent with your wardrobe. Paired with a cotton-wool Lycra peg skirt, it creates a monochromatic look to elongate your body. It works for nights at the opera or for casual errands with mittens and a ski hat.

THE AVIATOR (FAR RIGHT) Try a

very modern silhouette—a pair of softly draped wide-leg trousers that rest above the baby. Wear them with a stretchy turtleneck and a long scarf. Worn slim around the stomach, the pants make you look taller, elongating your legs. Very Amelia Earhart.

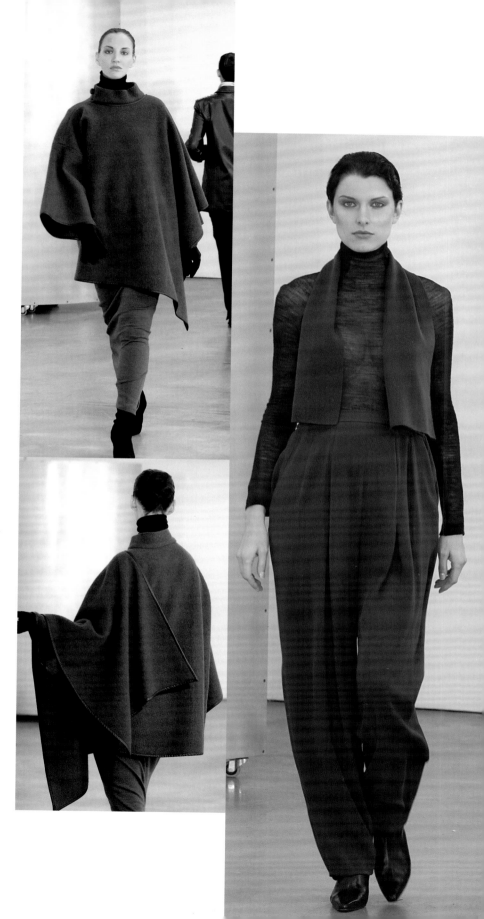

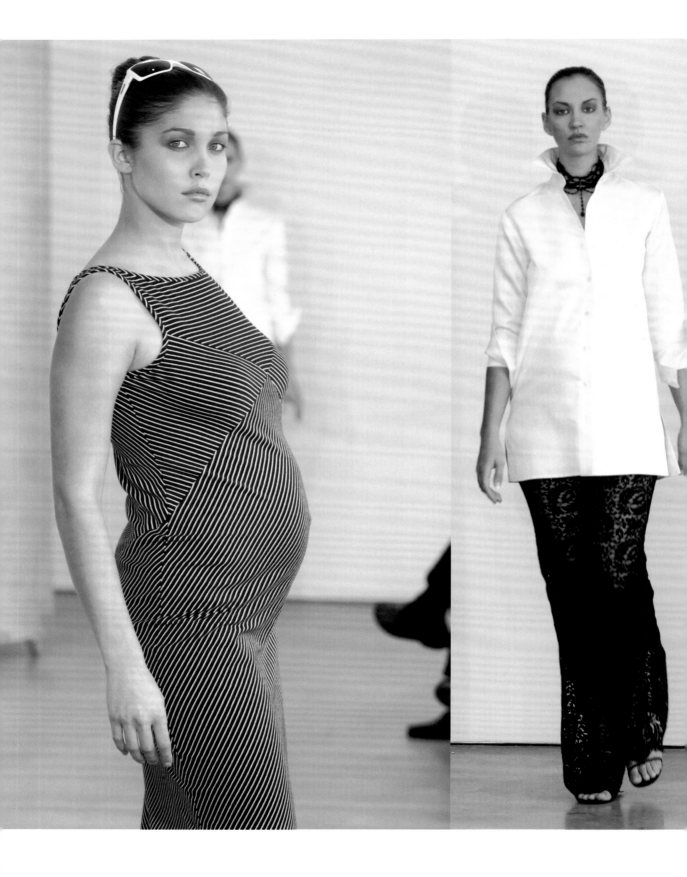

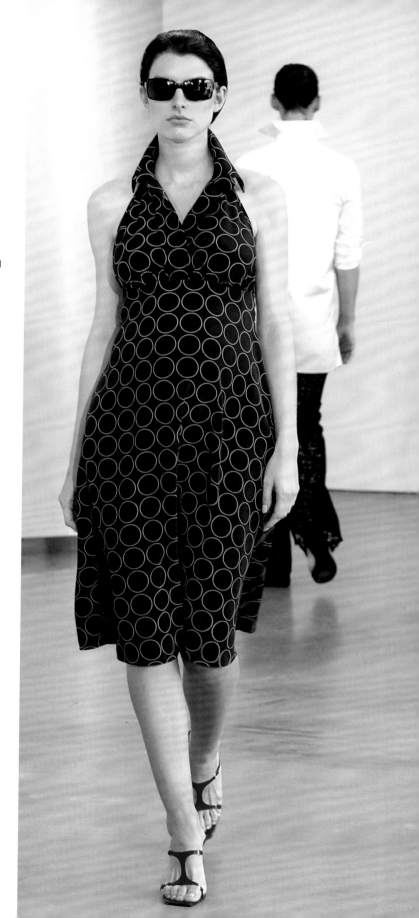

BRANCUSI DRESS (OPPOSITE LEFT)
Defy every rule your grandmother told
you and wear stripes! This simple
sleeveless chemise shift with sexy bias
stripes is ultramodern and easy. The
angled stripes show off your curves.

TAFFETA AND LACE (OPPOSITE RIGHT)
Bootcut pants and a button-down
shirt take a turn for the extraordinary
in black embroidered lace and silk
taffeta. Play with fabrics and texture
to dress up your everyday silhouette.
These two pieces are "evening
sportswear"—a versatile alternative
to buying a full-length gown. Choose
black opaque or nude lining under
lace pants, depending on your
desired effect.

THE JAYNE MANSFIELD DRESS
(RIGHT) A collared A-line halter dress
still works during pregnancy with an
Empire waist. Show off your great
shoulders, back, and neck. This dress
conjures up images of the most
glamorous woman you know—and
now is your time to step into her
shoes. The fitted quality of the A-line
dress has a terrific understructure for
maternity wear but creates a bare,
sexy, and clean look.

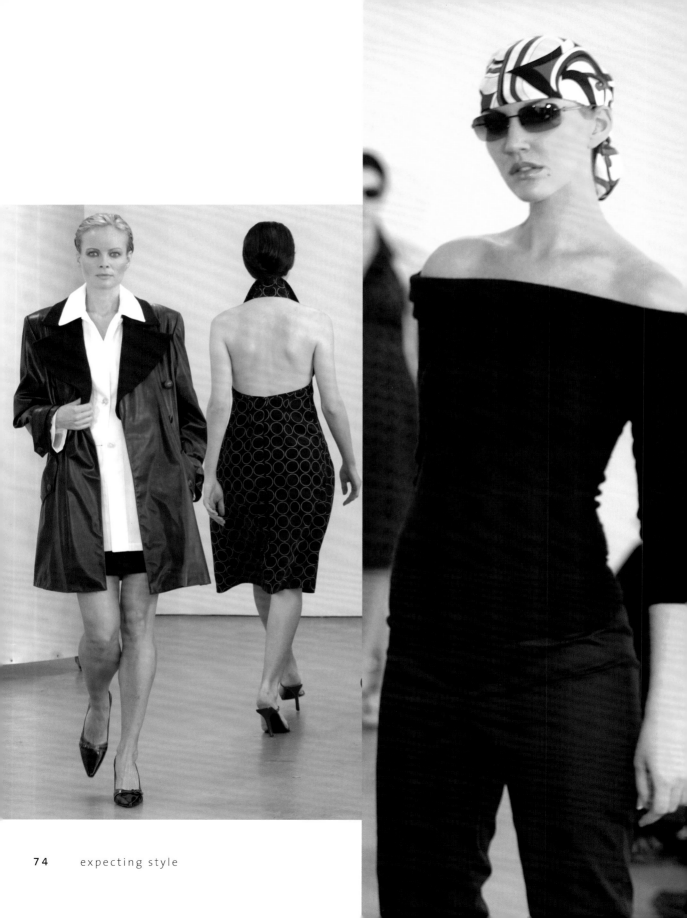

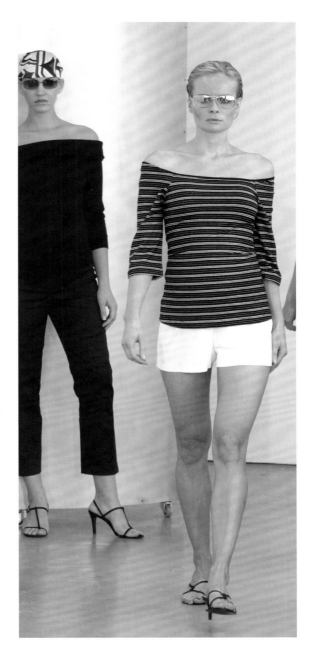

BURN RUBBER (OPPOSITE LEFT) Show off your legs in a miniskirt and a rubber trench coat. Accent your sexy legs by revisiting Catherine Deneuve chic with this above-the-knee-length raincoat paired with a no-waist miniskirt.

NIGHTS OF BLACK CASHMERE (LEFT) An off-shoulder top and three-quarter-length sleeves flatter your neck and shoulders. This can take you from the beach to black-tie events. Here, paired with black cotton capri pants, you can still look St. Tropez while in the family way. If you are one of those women who have always worn dark colors, try experimenting with the contrast of black fabric and exposed skin. With a scoop neckline, you can look clean and mod but still have the coverage you crave.

FRENCH RIVIERA (RIGHT) Dress as if you are on the beaches of Cannes with a fine-striped bateau-neck top with three-quarter-length sleeves and white terry-cloth shorts. If you've got it, flaunt it. This outfit is an inexpensive, impulse buy for a pregnant woman. Perfect for those who will be poolside.

SEXY BEADS (RIGHT) Give up nothing! A wool tube top with a beaded skirt and elastic waist looks even better on pregnant women who have curves to show. Who can resist the glamour of the elongated tube top with an easy pull-on skirt with a high slit? The top can be scrunched and personalized. The glitter skirt is seasonless and takes you from summer to winter. The tube top can be matched with yoga pants for a more casual look. Concentrate on buying evening separates when you are pregnant. They are more practical than full-length dresses.

THE OPERA SINGER (OPPOSITE LEFT) Make an entrance in a hooded cape with a strapless long Empire waist gown. The full-length cape is made of silver satin and is a great cover-up for pregnant women. Wearing a strapless gown and a hooded cape is a subtle way to separate your bust from a growing belly. This is white-tie dressing at its maternity finest. You don't even have to worry about fitting in—because you are stealing the show.

CARDIGAN GOWN (OPPOSITE RIGHT) Take the ease of your simplest nightgown and pair it with a matching elongated cardigan sweater. Texture and fluidity provide the drama here. Comfort is key; you will feel sexy and seductive in this. Gunmetal lace is a splurge but will become a staple of your post-pregnancy wardrobe.

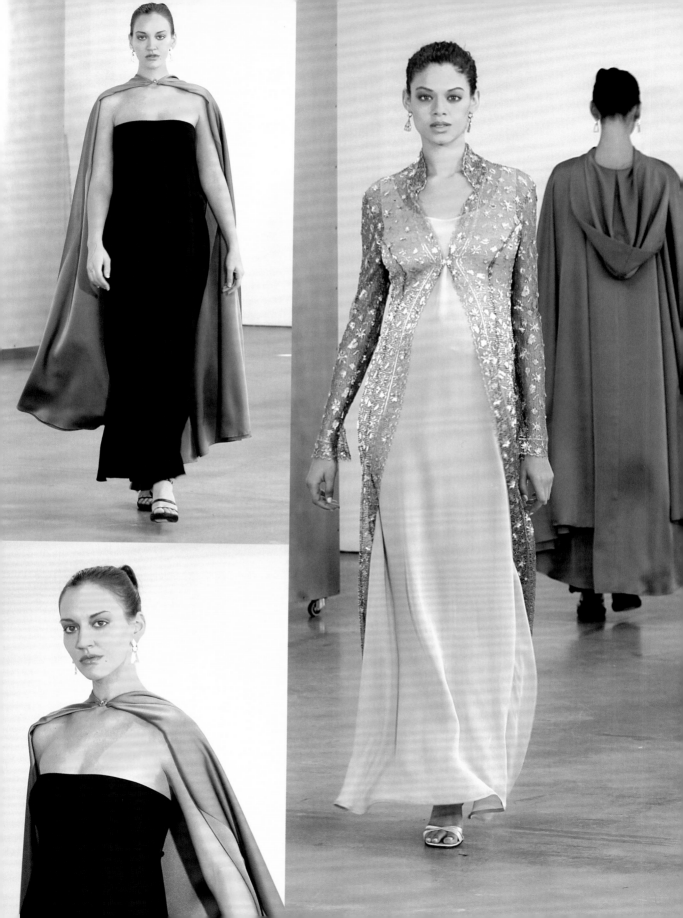

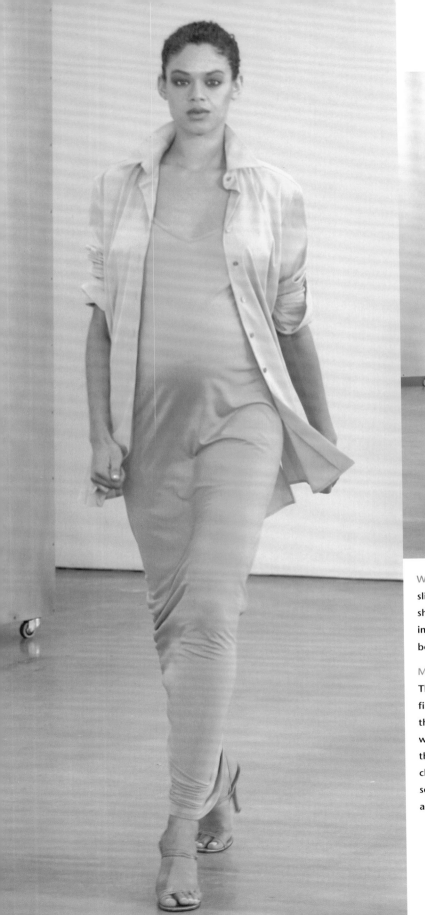

WARM WEATHER (LEFT) Pair a slinky dress with a breezy, tailored shirt in the same color. Notice the impact of color on an outfit. Do not be afraid of unexpected shades.

MARRAKESH MAMBO (ABOVE) This is at-home entertaining at its finest, but it can work outdoors by the pool or indoors for parties as well. Look for matte jersey fabric that is not too revealing in its clinginess. This is modern, very sexy, and universally flattering on all body types.

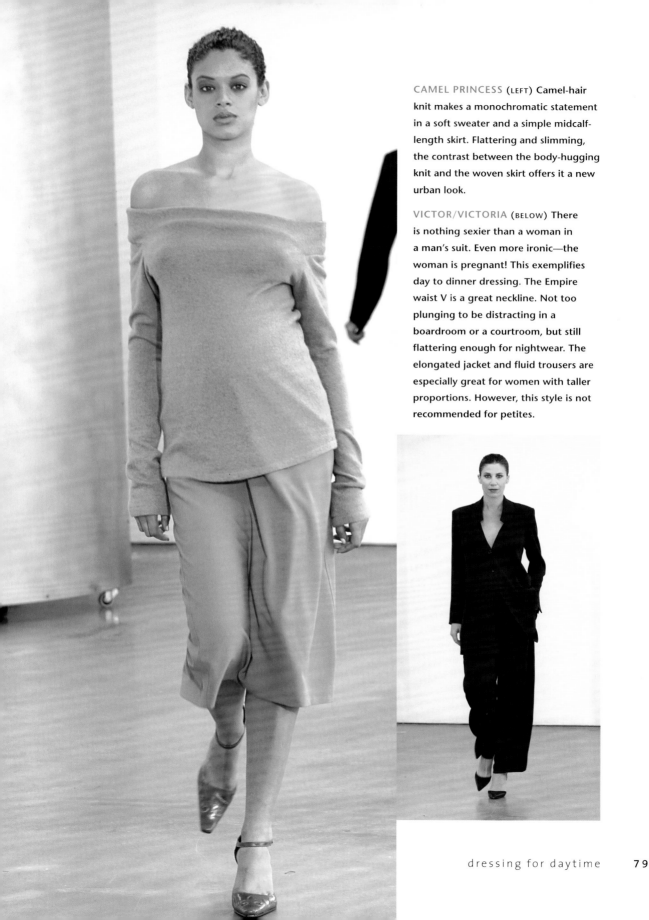

CAMEL PRINCESS (LEFT) Camel-hair knit makes a monochromatic statement in a soft sweater and a simple midcalf-length skirt. Flattering and slimming, the contrast between the body-hugging knit and the woven skirt offers it a new urban look.

VICTOR/VICTORIA (BELOW) There is nothing sexier than a woman in a man's suit. Even more ironic—the woman is pregnant! This exemplifies day to dinner dressing. The Empire waist V is a great neckline. Not too plunging to be distracting in a boardroom or a courtroom, but still flattering enough for nightwear. The elongated jacket and fluid trousers are especially great for women with taller proportions. However, this style is not recommended for petites.

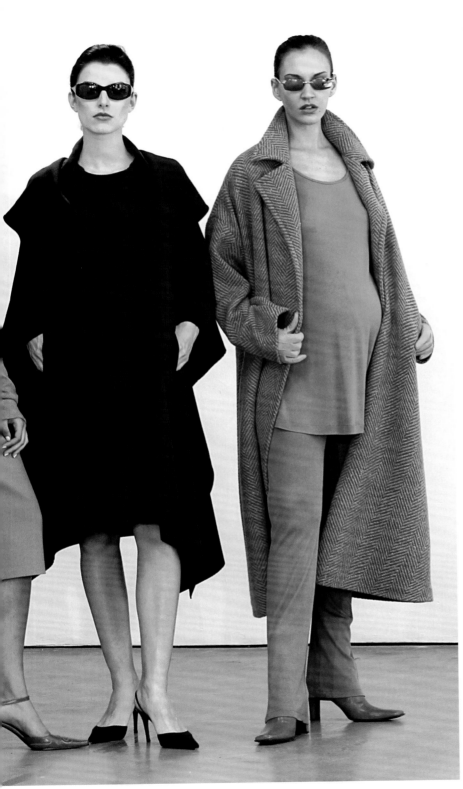

DRAPED COAT/DRESS

(FAR LEFT) This coat-cloak-dress lets your new curves shine through. The asymmetrical hem makes a modern statement. The drapery does not overwhelm your new figure. A showstopper.

COMFORT COOL (LEFT)

A slouchy, oversized, notch collar, swing wrap coat with no closure in a terra-cotta herringbone paired with matte jersey separates is an easy alternative to casual. The monochromatic color makes it an ensemble, but all three pieces work as separates as well.

ROAD-TRIP GEAR (OPPOSITE

LEFT) Pair a cowl-necked pullover with camel-ribbed stretch riding pants for easy weekend dressing. The texture of the fabric and the monotone look keep you looking trim and polished.

THE NEW SUIT II

(OPPOSITE RIGHT) The same dress with an elongated jacket in a different color becomes the maternity variation of the power suit. With a slightly lower neckline, it creates a great canvas for your personal jewelry.

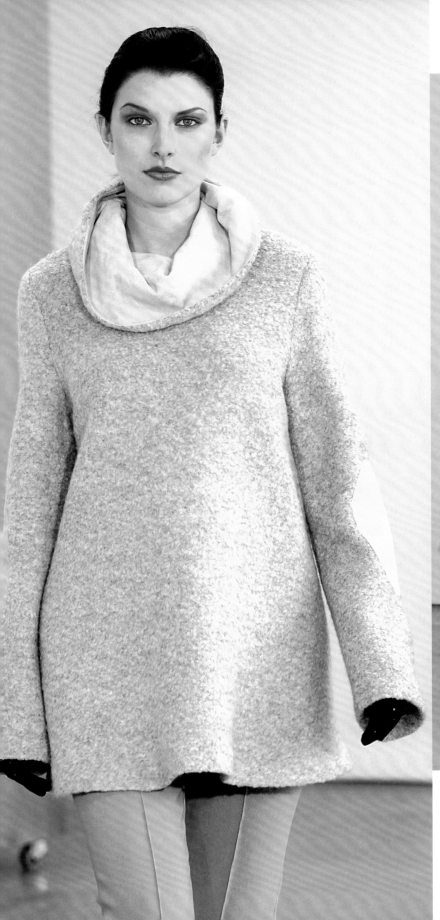
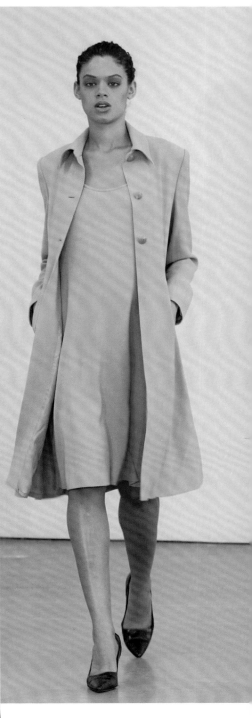

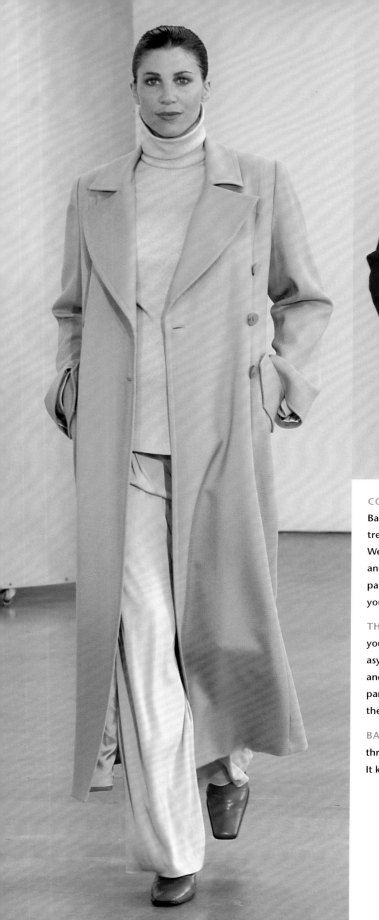

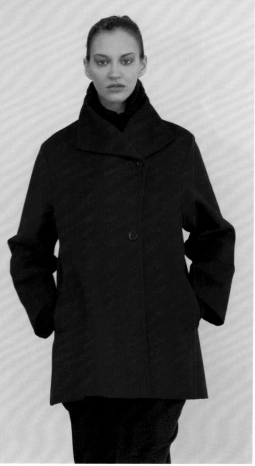

COUNTRY CLASSIC (LEFT) Channel Lauren
Bacall in this blond, double-breasted long
trench coat. Leave the belt for next season.
Wear it with a buttery, oversized turtleneck
and softly draped winter white elastic
pants. So comfortable, you will feel as if
you are almost wearing sweatpants.

THE SABRINA (ABOVE) Here is something
you can find at a vintage store. An
asymmetrical, A-line merlot-colored jacket
and easy, elastic pull-on espresso-shade
pants. Try a coat with high buttons above
the belly.

BABY ZHIVAGO (OPPOSITE) Another great
thrift store find can be a fur or faux fur coat.
It keeps you warm when you need it most.

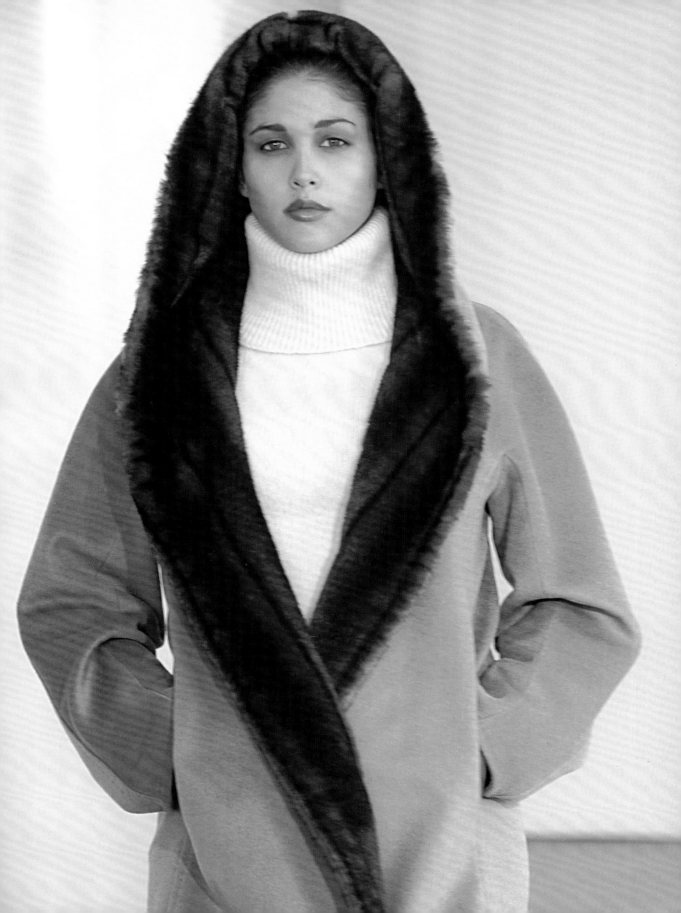

4. red -carpet nights

"This is a terribly serious subject to me. I adore dressing and I adore making up. I adore the procedure—it is terribly invigorating, my getting ready to go out in the evening. It gives me such pleasure."

—Diana Vreeland

On those nights when you have to look your best—
a black-tie dinner dance, gala opening, or other formal
occasion—stay true to your pre-pregnancy style.
There is nothing as beautiful as an exquisitely
turned-out expecting mother in a fantastic evening dress. It is
downright sexy.

Though this may not be the ideal time to try the latest fashionable trend (unless, of course, you already keep abreast of the latest looks—then indulge away), it is also not the time to finally discover your inner frowsy matron. Be true to yourself and revel in your

new shapeliness. Discover parts of your body that are suddenly in bloom. Celebrate yourself, and invest in a few pieces that will take you from your friend's wedding to opening night at the opera, to an after-work gathering, and beyond.

Celebrities from Annette Bening to Vanessa Williams and Stephanie Seymour have perfected the look of a glamorous pregnancy. This chapter reveals what style cues they followed, what fashion and beauty secrets they adhered to, and how they achieved their own unique way of handling their new shape. For red-carpet nights, each woman is her own cottage industry—and whether you have ten handlers or none, this chapter shows you how to shine on the nights when all eyes are on you.

Find yourself in these pages as you evaluate your own personal pregnancy style. Whether you are an ethereal hippie, a sexy bombshell, a shy ingenue, a minimal classicist, or even a combination of styles, you'll find the perfect outfit for every special occasion.

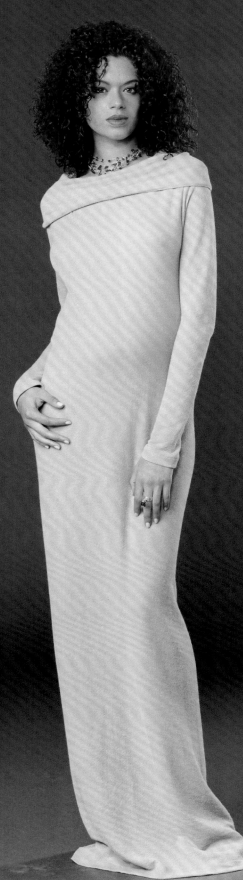

the bohemian

She wears Indian embroidered mules and jasmine-scented perfume, and carries an antique tapestry bag as a precious accessory. Basking in the glow of her new shape, she revels in her newfound voluptuousness, lounging in flowing silk pajamas and bell-sleeved tunics. Her clothes match her whimsical nature, with bohemian detailing, medieval inspiration, vintage provenance. Her taste in jewelry is eclectic and unique—an oversized turquoise pendant, perhaps, or a one-of-a-kind cocktail ring. She is as comfortable at the wheel of a pickup truck as in the front row of the ballet, and she is an active member of the PTA as well as the repertory theater in her hometown. She gives "barefoot and pregnant" a whole new meaning. Flowers in her hair? She may have left her heart in San Francisco, but her feet are firmly planted on the ground.

During their pregnancies, celebrities such as Uma Thurman, Susan Sarandon, and Mia Farrow gravitated to the rich hippie style to complement their unique and unconventional personalities. Whether you are a rich hippie or just want to dress like one, these four silhouettes are perfect for the evenings when you are feeling a little fanciful and playfully spirited.

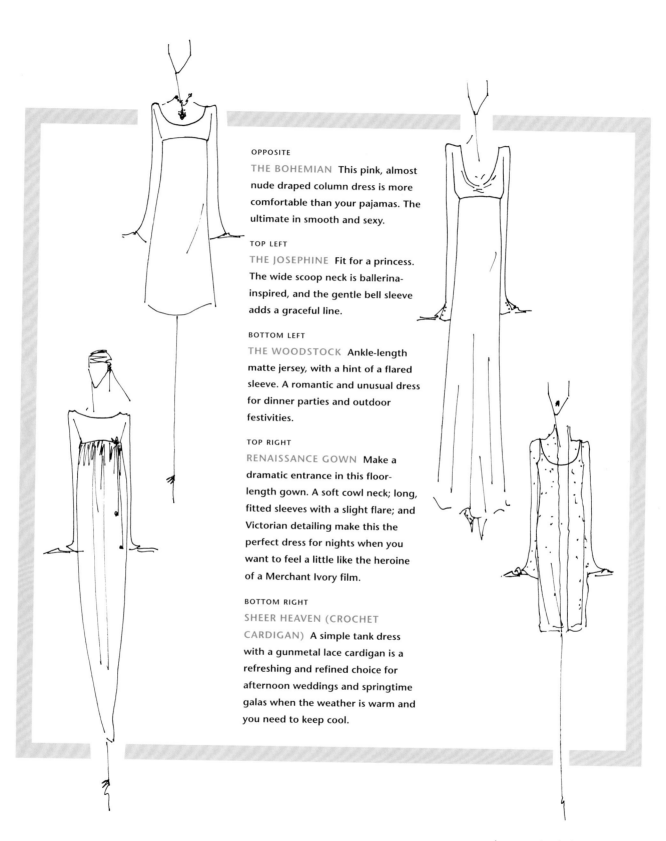

OPPOSITE

THE BOHEMIAN This pink, almost nude draped column dress is more comfortable than your pajamas. The ultimate in smooth and sexy.

TOP LEFT

THE JOSEPHINE Fit for a princess. The wide scoop neck is ballerina-inspired, and the gentle bell sleeve adds a graceful line.

BOTTOM LEFT

THE WOODSTOCK Ankle-length matte jersey, with a hint of a flared sleeve. A romantic and unusual dress for dinner parties and outdoor festivities.

TOP RIGHT

RENAISSANCE GOWN Make a dramatic entrance in this floor-length gown. A soft cowl neck; long, fitted sleeves with a slight flare; and Victorian detailing make this the perfect dress for nights when you want to feel a little like the heroine of a Merchant Ivory film.

BOTTOM RIGHT

SHEER HEAVEN (CROCHET CARDIGAN) A simple tank dress with a gunmetal lace cardigan is a refreshing and refined choice for afternoon weddings and springtime galas when the weather is warm and you need to keep cool.

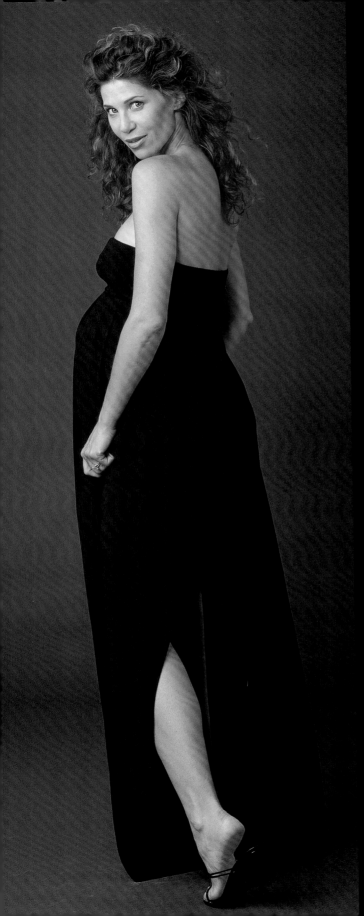

the bombshell

The traffic-stopping, belly-baring bombshell commands the center of attention at any social gathering. She is the blonde in the heels and the cut-to-there dress, or the brunette who smolders with Rita Hayworth–like passion, the one whose legs will not quit, with a mind for business, a body for sin, and clothes that fit in all the right places. Pregnancy has brought out the best in her curves, and since she's got it, she's going to flaunt it. Whether she is getting ready for brunch with her friends, her son's bar mitzvah, or a poolside party, this is a woman who likes her wardrobe to make a statement: sexy. She can be found at the Philharmonic as well as the country club, and she is not afraid to pull out all the stops for black-tie events. Like Elizabeth Hurley, she might wear the dress only once, but the pictures will be worth it. Her attitude is black-tie bar none.

Faith Hill and Jada Pinkett were the epitome of the pregnant bombshell who preferred body-hugging gowns to celebrate their new shape. Take a cue from their body-conscious confidence and stop feeling skittish about showing some skin—you may finally be filled out to your best advantage, so go ahead—indulge a little.

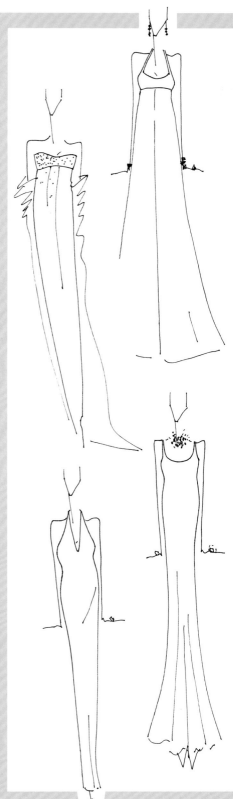

OPPOSITE
KICK UP YOUR HEELS The sexiest strapless gown there is. With a slit as high as you dare. The perfect skin-baring gown for major jewelry. Va-va-voom!

LEFT, CLOCKWISE FROM TOP
TRAFFIC-STOPPER (HALTER) Halt in the name of love! Dare to bare in a dress that is as elegant as it is seductive, as well as universally flattering for all shapes and sizes. Make it your New Year's Eve gala perennial. Elongating shoulders, glowing skin, this is great to show off a toned back—biceps, triceps, everything shows.

A FULL TANK A body-fitting tank column with matching wrap trimmed in coque feathers trailing behind in a dramatic train while the knitted column hugs every single curve on your new bodyscape. Great stretchy knit—it is as sexy feeling as it is looking.

TAKE THE PLUNGE The most fun leap you may take for nine months. The plunging V neck is a sultry and seductive choice for an evening when you cannot help but want all eyes on you.

BEADED LADY (BEADED BRA) A beaded strapless dress delivers maximum glitter and high-impact glamour in one deliciously simple package. Forgoing not one sequin of luxury, quietly steal the show.

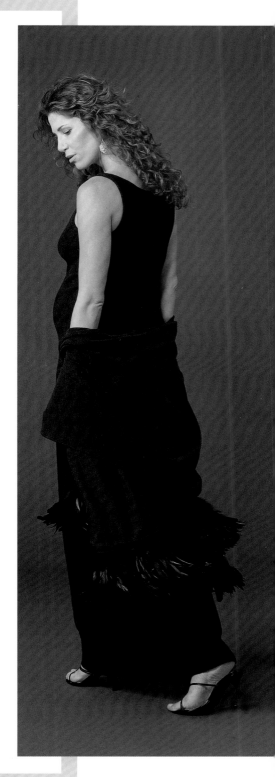

the ingenue

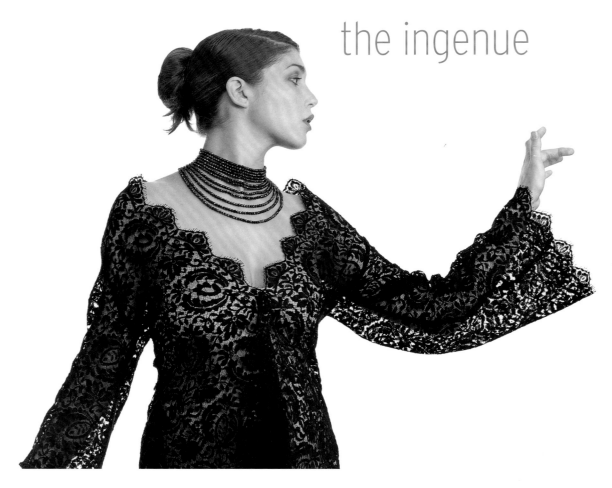

By this day and age, the ingenue has chucked her Fair Isle sweaters and wide-wale corduroys for cashmere turtlenecks and A-line skirts, kitten heels, and a great leather bag, but she still favors her velvet headband and cordovan penny loafers. She is drawn to well-made clothes with classic tailoring and a demure shape, and is partial to Elsa Peretti bean necklaces, Cartier tricolor bands, and her grandmother's pearl earrings. She is Audrey in *Roman Holiday*, with a little of Grace from *Rear Window* and Camelot-era Jackie thrown in for good measure. Her look is simple and chic, exquisite and clean, and always appropriate. Head of the Junior League or chairwoman of the charity ball, she is active and athletic, carrying her pregnancy with grace and good humor.

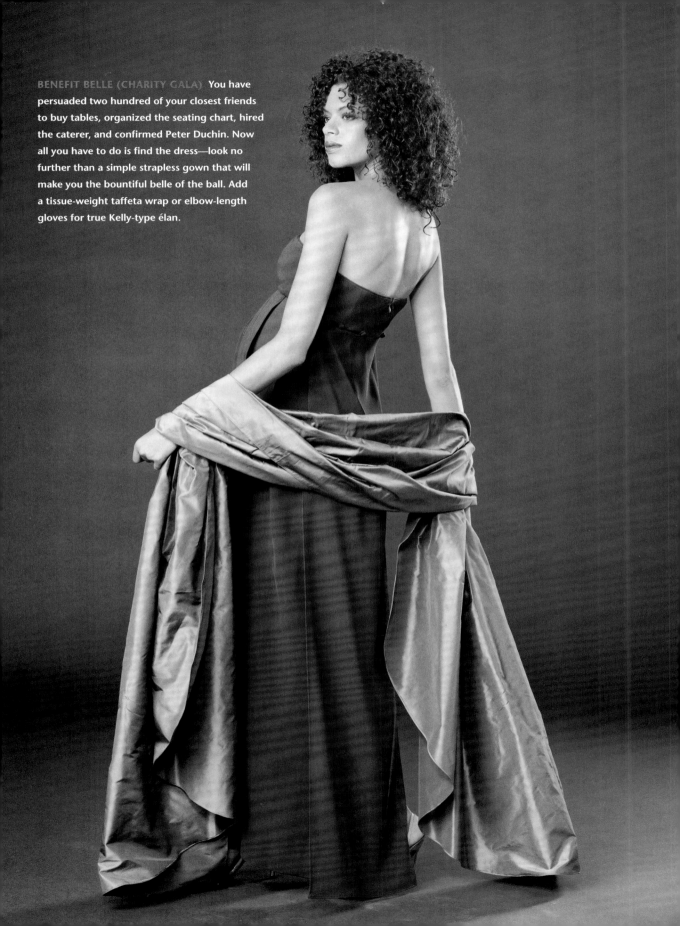

BENEFIT BELLE (CHARITY GALA) You have persuaded two hundred of your closest friends to buy tables, organized the seating chart, hired the caterer, and confirmed Peter Duchin. Now all you have to do is find the dress—look no further than a simple strapless gown that will make you the bountiful belle of the ball. Add a tissue-weight taffeta wrap or elbow-length gloves for true Kelly-type élan.

TOP LEFT
EMPIRE GOWN A traditional favorite, the Empire waist gown is cap-sleeved and scoop-necked and enhances your new shape with decorous restraint.

BOTTOM LEFT
CHARLOTTE For Park Avenue princesses and soccer moms alike who like to emulate the young Jackie O, the Charlotte's chemise and jacket can be made from a variety of fabrics, from silk to rare tropical wools. It can easily take you from lunch with the girls to a gallery opening or evening corporate functions.

TOP RIGHT
COUNTRY CLUB COOL A shorter version of the Benefit Belle, its knee-length hemline works for less-formal events and evenings at the country club. Throw a cashmere sweater over your shoulders for a jaunty touch.

BOTTOM RIGHT
AUDREY She would have loved this shirtdress's oversized corsage and blouson sleeves. Try it with simple flats (better for your weary ankles) for a more relaxed evening look.

OPPOSITE
SWING OUT This V-necked beaded swing dress is flirty, spunky, and fun—just like you.

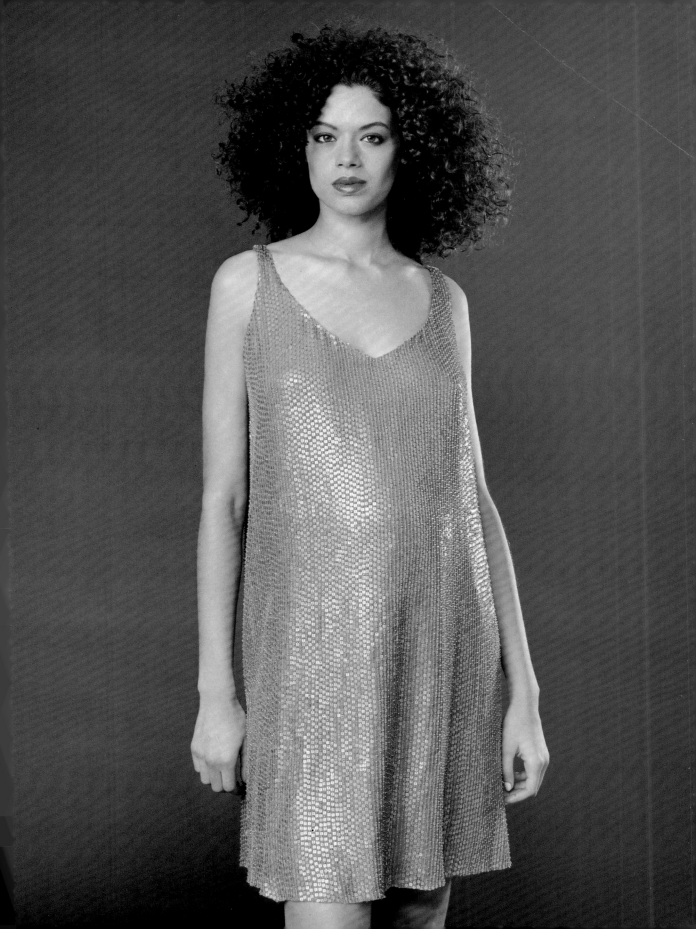

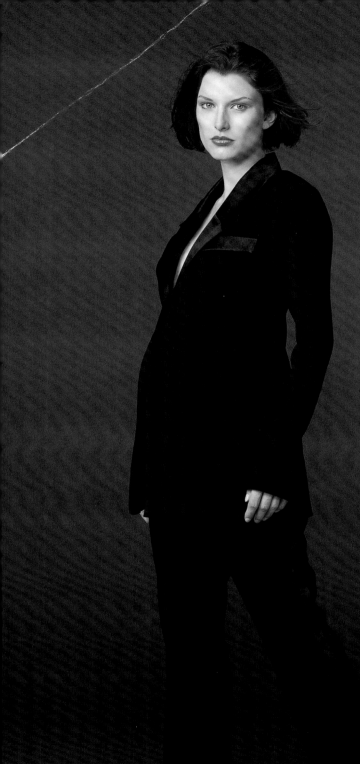

the minimalist

She has got blueprints rolled up in her drawer, and a studio she calls home. The minimalist favors impeccably designed clothes with an arty flavor. Her clothes are sculptural and uncluttered. She is obsessed with details and perfection—the buttonhole is as important as the button. She is partial to severe silhouettes, sumptuous fabrics, and Japanese flourishes. In her closet is an arsenal of well-cut suits. She wears almost no jewelry and hardly any makeup, but she is always flawlessly turned out.

Annette Bening and Jodie Foster are minimalists with an eye for detail and a taste for quiet sophistication. Whether an artist or just someone who wants to dress like one, every woman could use a few easy timeless pieces in her pregnancy wardrobe, where line and silhouette speak for themselves, and where less is truly more.

OPPOSITE

TUXEDO For those of us who have always dreamed of wearing a man's dapper tuxedo. Here's a great take on the subtle details that make for a black-tie suit.

TOP LEFT
SUIT YOURSELF (QUIET SUIT)
A tailored jacket and matching soft, wide-legged pants are a sharp and elegant choice for an evening suit. A one-button closure and an Empire silhouette are the utmost in simplicity.

CENTER LEFT
TURNING JAPANESE (EVENING KIMONO)
This kimono-inspired evening coat is a one-of-a-kind piece that is both comfortable and exotic. Its clean lines and Asian influence complement any shape and are especially flattering for tall women.

BOTTOM LEFT
NEW YORK STATE OF MIND (EMPIRE WAIST WITH WRAP)
The strapless Empire waist dress is urbane and the essence of uncomplicated style. Pair it with a luxurious wrap of silk taffeta or the softest cashmere.

RIGHT
THE MAHARAJA (EVENING TUNIC AND PANTS)
A sleeveless, floor-length gray tunic and matching wide-legged navy pants in double-layer silk georgette is an unexpected and marvelous alternative to a traditional gown. Wear it to the museum gala or to the beach house; it works for any occasion.

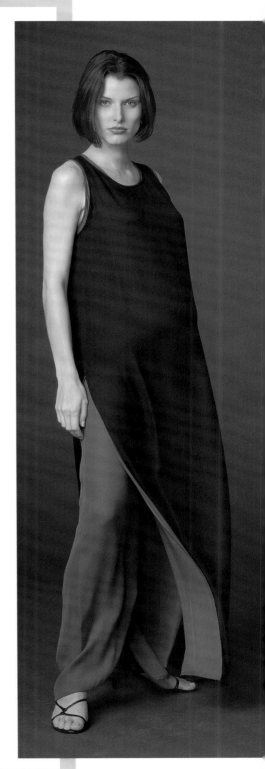

very, very special occasions

If wedding bells are ringing in the immediate future or if you have been asked to be a bridesmaid for a wedding, there is no need to despair. There is no need to hide or deny or obscure your pregnancy. Instead, revel and rejoice in it—there are many ways to incorporate your newfound voluptuousness in a dignified manner.

being the bride

If today is your day—all three of you—congratulations indeed! There is no need to tell you that the blushing pregnant bride is an anachronism in this day and age. In fact, the sight of a blissfully pregnant bride is a now-familiar sight on both coasts, from Hollywood actresses to New York City socialites who have shown there is no need to postpone, cancel, or hasten the wedding in order to accommodate a due date.

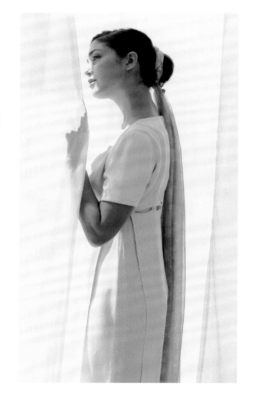

The most important factor to keep in mind in choosing your wedding look is proportion. Keep your gown simple and your accessories to a minimum. You do not want to distract from or conceal your shape by choosing an immense bouquet of flowers, for example. And that cascading floor-length veil might prove to be cumbersome rather than idyllic.

being a bridesmaid

Fearful of sticking out like a sore thumb in the wedding party simply because of your pregnancy? There is no need to feel like a pumpkin among a field of willowy stalks, as there are many ways of looking as, if not more, beautiful than any of the other attendants.

Matching the fabric of the other bridesmaid dresses is the easiest way to blend in. While the dress silhouette might have to be rethought for your shape (especially for waist-fitted dresses), you can always match the feel of the wedding by perfectly matching the chosen hue of the bridesmaid dress.

**The bridesmaids wore red . . .
and there were no exceptions.**

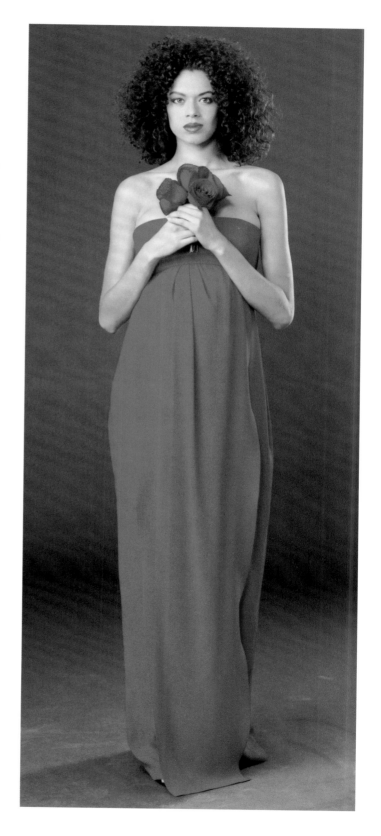

5. sweat-proof style

Staying fit has always been part of your life. Your first instinct now may be to slow down a bit, but how do you lower your pulse without grinding to a stop? In this chapter, athletes show how they cooled their pace without losing their shape and describe how they went from world-class athletes to expecting moms—and then regained their competitive edge.

Your gym bag is a precursor to your diaper bag. Keep things neat and orderly, from your water bottles and goggles to your workout gloves and tennis shoes.

This chapter covers workout clothing and what to look for in terms of comfort and support; includes tips from trainers and celebrity athlete moms; and doctors and nutritionists weigh in on the prescribed way to retailor your own personal routine. Yoga, Pilates, swimming, and walking are four recommended, safe yet effective workouts for mothers-to-be. Here is how to be appropriately dressed for each activity.

rules of the game

It is easy to slack off and look a little messy at this time in your life because of the changing state of your body. This is compounded even more when you are mobile. This section provides general guidelines and a summary of what to follow for safety, comfort, and style when choosing exercise clothing. Whether it's tennis, swimming, stretch class, or walking with your friends, choose neat garb. You're still going to need the smallest, most chic Walkman and wristband, a great-looking water bottle carrier, maybe even a battery-operated fan. Even tennis skirts can be turned maternity by putting the tummy panel in— just refer to steps in Chapter 2. Do not hide in the back row just because you're afraid of the mirror. Your gym bag is the precursor to how you will manage the diaper bag. Learn to keep things organized— your Walkman, lip balm, and water bottle. It is good practice for when you have to lug around diapers, baby bottles, blankets, bibs, and everything else under the sun.

"Generally, pregnant women can continue their exercise regimen as long as they feel comfortable. Avoid strenuous aerobics, but light-to-moderate-impact aerobics is healthy. Exercise makes for better pregnancies and better deliveries. The only downside is that if you are out of shape and have not previously exercised, you should not start when you are pregnant. But if you are in shape, you can continue to do anything you normally would. Take frequent breaks to hydrate. And if you are crampy, short of breath, or not feeling well, stop immediately. A common misconception is that pregnant women cannot do abdominal work. You certainly can, until you do not feel comfortable. Pregnant women have softened cartilage and ligaments, so try to refrain from sudden backward or forward movements in tennis, or straining and stretching in yoga. As long as you are not playing supercompetitive tennis, go ahead. Weight training is also fine, although keep to light repetitions to tone, not build muscle mass. Other than deep-sea diving, pregnant women can do anything, really!"

—Dr. Lynn Friedman, OB-GYN,
Mt. Sinai, New York City

yoga

Although you will be able to start practicing yoga after you become pregnant, it is certainly not the time to experiment with challenging poses. It is more advisable to start before you get pregnant. If you have been doing yoga for a while, you can continue to do everything you were doing before, just with some slight modification.

Breathing exercises in yoga calm your mind and body.

In general, yoga is great preparation for childbirth. It opens your body's channels and strengthens your mind. By using different breathing techniques, such as the *pranayama* (breath), you can learn how to relax your body. If you can control your breathing, you can control your mind, and it helps you focus during labor. Physically, it helps increase your stamina and endurance. There are great exercises to strengthen your lower back and abdominal muscles. As your belly gets bigger, you are going to need that lower-back strength—pregnancy brings a lot of stress and pain to your back.

The main benefit of yoga is that it relieves stress. In certain poses, like the Warrior poses, you can envision yourself as a strong, solid woman. The visualization techniques relax your body and bring you an inner focus that helps get you through all the contractions. Yogic breathing can be applied during all stages of pregnancy, even if complications occur. It is a good way to calm the nervous system and promote relaxation.

The following yoga poses are recommended for pregnancy:

- **THREE-PART BREATH** Breathe by closing your mouth and inhaling and exhaling through your nose. It calms the mind and relaxes the body.

- **VICTORIOUS BREATH** Create a hissing sound in the back of your throat to lengthen inhalations and exhalations. Keep this breath through your entire yoga practice if possible.

- **MOUNTAIN POSE** Improves posture, alignment, and balance; strengthens your legs and buttocks.

- **EXTENDED MOUNTAIN POSE** All the benefits of the Mountain Pose, but also stretches your shoulders.

- **CHAIR POSE** Promotes good balance; strengthens your ankles, thighs, calves, and spine; stretches your shoulders and chest.

- **WARRIOR POSE** Relieves back pain, especially through the second trimester; strengthens and stretches your leg muscles and ankles; stretches your groin, chest and lungs, shoulders.

- **CAT-COW STRETCH** Improves circulation; increases suppleness of your spine; stretches the muscles along your back, neck, and arms; offers lower back relief, especially in the second and third trimesters.

"If you have been enjoying a regular yoga practice, you can continue your practice with slight modification during these early stages. I advise to discontinue full 'wheel' or back bending. I also advise against poses that require you to put pressure on your abdomen. You are going to need to give up sleeping on your belly, so it is a good idea to avoid lying on your belly in yoga practice also. It is also the time to give up and avoid deep twisting poses. Inversions such as headstands, handstands, and shoulder stands, if practiced carefully, can be continued. Let your body (and your doctor) be your guide. Please note that balance begins to shift with your changing body, so it is best to practice inversions against a supported wall."

—Renee Parli, yoga instructor

- **BOUND ANGLE OR BUTTERFLY POSE** Improves posture; helps open your hips, important during pregnancy; stretches your groin muscles.

- **CHILD'S POSE** Gently stretches your lower back; calms the body, mind, and spirit; provides deep relaxation and rejuvenation; promotes a sense of security and nurturing; spreads the knees apart to allow for your growing abdomen.

Please consult your doctor before beginning any exercise regimen. Do not attempt poses that constrict your abdomen. In all poses, space should be created for your abdomen. There should be no straining or discomfort.

CLOTHES AND EQUIPMENT

- Buy your own yoga mat. So much better than using the one at the gym.

- Roll it up in a chic new black yoga mat bag from Nuala.

- Now is the time to utilize all the yoga pants you've been amassing!

- Do not wear your ratty oversized T-shirt, wear a fitted shirt with Lycra in a flattering color.

- Bring a pillow for cushioning your joints.

pilates

Pilates is a great prenatal exercise. But if you never did Pilates before you were pregnant, do not start when you are pregnant. Pilates works some very deep, core muscles, and it might be difficult for someone newly pregnant who has never tried it before. It is wonderful to take Pilates if you are planning to become pregnant. It will take you through your entire pregnancy. If you know you are going to be pregnant next year, start *now*.

There are no strong twisting or jarring movements in Pilates. It is a nonimpact exercise, with no pressure on the joints, and a focus on breathing. It is very effective at toning. It is about precision, not brute force—and gentle enough for a pregnant woman to practice throughout her pregnancy. It works the core abdominal muscles, which are important during delivery. The more toned your muscles remain during pregnancy, the easier it will be to get your body back afterward. You lose a lot of elasticity in your skin and muscles during pregnancy. Pilates helps "lift" your muscles back after birth, and the mat exercises are great for reverse gravity—they pull everything back up. The concentration on exhaling is absolutely helpful for childbirth.

"Pilates works with your body's natural order—the organs, muscles, ligaments, and joints. Nothing works outside of your natural frame in any way that might jeopardize the safety of your joints and muscles. When done correctly, it is very safe. It also enhances circulation, which is very important during pregnancy."

—Brooke Siler, author of
The Pilates Body and *The Pilates Body Kit*,
and owner of Re:AB

CLOTHES AND EQUIPMENT

- Dance gear: Leotards and unitards are great options for Pilates.

- Leggings and sweatpants from Athletica, Puma, Victoria's Secret, and Adidas are great choices. You do not want to wear pants that fall below your waist when you are at odd angles.

- T-shirts or tank tops that fit well and are 100 percent cotton: Wear slimming clothes that keep your belly covered.

- Do not forget workout gloves and a water bottle.

Tie your hair back neatly so it does not fall in your face.

swimming

Swimming is a great workout for expecting mothers; it is less strenuous than jogging and very enjoyable. Since you are kept buoyant by the water (and weigh only one-tenth of your "land" weight), it is a treat for a growing belly. You can work out longer and more intensely without feeling the effects. Swimming is easy on your joints and helps you keep your muscle tone. Also there's no need to worry about becoming overheated, since the water keeps your temperature down. You may find that taking to the water is something you can do up until labor. It is a relaxing and rejuvenating way to work out, so put on your swim cap and make a splash.

Look for bathing suits sized for taller women, to give you the extra fabric for your extra width. A bathing cap is de rigueur.

Support and structure are important in choosing a bathing suit. Look good from all angles.

CLOTHES AND EQUIPMENT

- Tie your hair back neatly.

- Look for flattering swimsuits for a pregnant body. Old-fashioned bathing suits with short shorts are particularly cute on pregnant women.

- Some bathing suits are sold with tops and bottoms separately—you can buy a size eight top and a size ten bottom if necessary.

- Look for bathing suits sized for taller bodies. They provide the right amount of extra fabric that you need for your growing width.

- Wear a bathing cap so you do not get chlorine in your hair. Old-fashioned bubble caps and racing swim caps keep your locks covered.

- Do not forget your goggles.

- A water-resistant watch helps you keep track of how long you have been in the pool.

PLAYING IT SAFE

"With both my pregnancies, I continued to skate and perform a lot of exercise. I felt well and I did not feel sickness, just a little nausea, so it was not difficult. I skated until a month and a half, two months. I was still standing on the ice at five or six months, and slow-jogging every day. At seven and a half months, I could not jog anymore, so I did a lot of walking. But at eight months, I could not even walk anymore. I did a lot of warm-up exercises, you cannot do sit-ups but walking really helped.

"Being fit, I think I had easier pregnancies. My muscles are pretty tough and I think they helped hold the baby until my delivery date. Regular women have more relaxed muscles, but our muscles are so strong. I am so used to feeling uncomfortable and having my body stretched to the limit. I think as an athlete I was better able to handle the discomfort of pregnancy."

—Ekaterina Gordeeva, Olympic champion figure skater

6.
on the
road

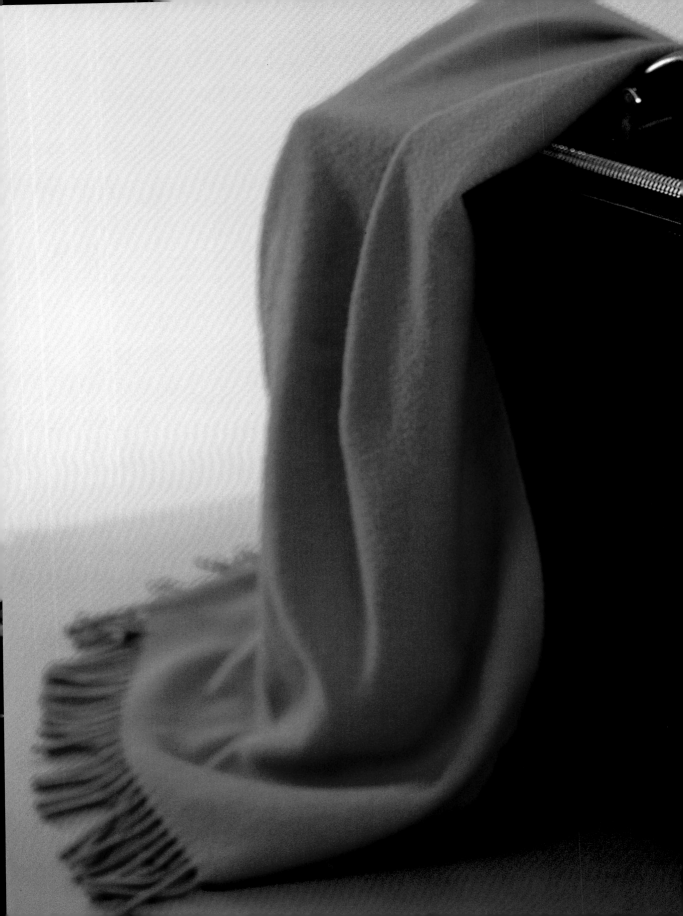

This chapter offers organizational tips for traveling while pregnant, for business or leisure. When you are pregnant, it is important to travel light and dress comfortably. Whether you are going away for a week or a weekend, organization counts more than ever. Profiled in this chapter are the key travel pieces you will wear over and over again for their versatility and comfort. Remember to look for things that are weightless themselves. Whether you keep to a monochromatic wardrobe (as suggested here, in white or black) or prefer to wear color, there are a few basic requirements for your suitcase.

the well-packed suitcase

These nine pieces are wrinkle- and crunch-resistant, light, easy, made of breathable fabrics, so be sure to always pack them all.

PRECEDING PAGES
A sturdy suitcase and a pashmina shawl are travel essentials.

LEFT
Grab and go. A canvas carry-on with wheels is the best bet.

ABOVE
All you need for a weekend trip: a small handbag for your wallet and keys, a large carryall, an umbrella, sunglasses, a hat, comfy socks, and slip-on loafers.

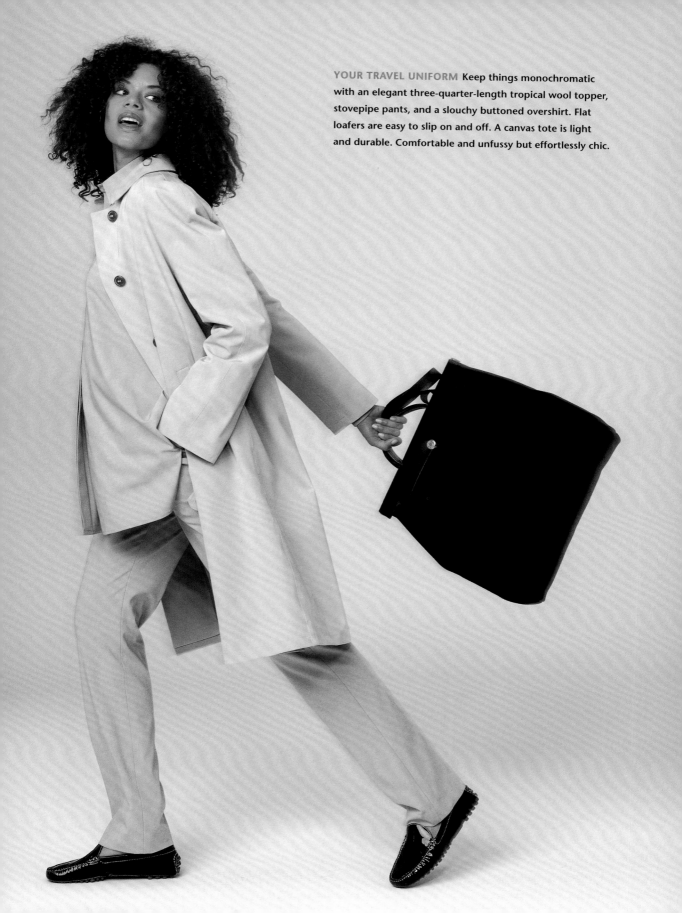

YOUR TRAVEL UNIFORM Keep things monochromatic with an elegant three-quarter-length tropical wool topper, stovepipe pants, and a slouchy buttoned overshirt. Flat loafers are easy to slip on and off. A canvas tote is light and durable. Comfortable and unfussy but effortlessly chic.

BELOW

The little black dress travels with you anywhere. Look for one made of wrinkle-resistant fabric that can be folded easily and rolled up for minimum space.

LEFT FROM TOP

The packable trench: one topper is all you need; a no-waist or elastic-waist slip skirt sees you through everything from conferences to social gatherings; a sexy, inexpensive body-hugging shell can be paired with anything.

CENTER FROM TOP

The take-anywhere turtleneck dress; travel trousers: stretch ankle-length pants are cozy and soft.

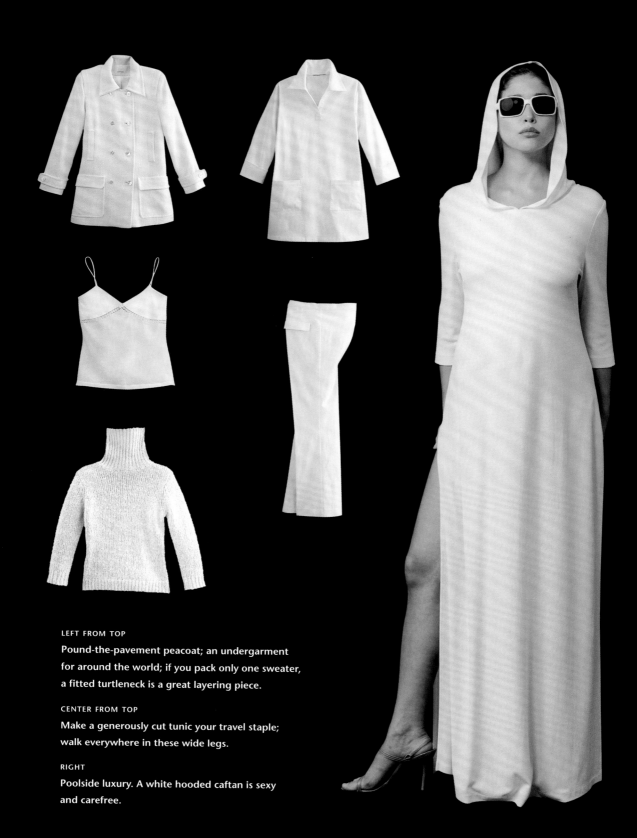

LEFT FROM TOP

Pound-the-pavement peacoat; an undergarment
for around the world; if you pack only one sweater,
a fitted turtleneck is a great layering piece.

CENTER FROM TOP

Make a generously cut tunic your travel staple;
walk everywhere in these wide legs.

RIGHT

Poolside luxury. A white hooded caftan is sexy
and carefree.

journeywoman outfits

Traveling is the litmus test of your maternity shopping, as each piece needs to justify its space in your suitcase.

 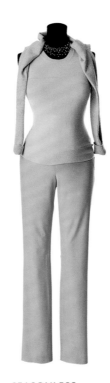 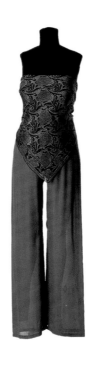 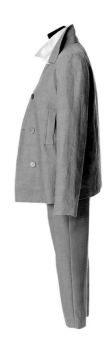

SHOW OFF YOUR CURVES Bring a selection of scarves to spice up an outfit. Here, a Lycra bodysuit and a no-waist skirt strike a Parisian pose with the red scarf. The Lycra will not bunch up in your suitcase, and the skirt can be worn above or below the belly to change its length.

SEASONLESS SWEATER SET The neutral shade is ideal for travel in all climates. These three easy pieces work from day to evening.

SEXY SCARF TOP Try a printed scarf with georgette pants. Fold the scarf diagonally so it can hug your new curves. The scarf top is perfect for poolside or for evenings out.

ALL-AMERICAN MOM A tailored peacoat and cropped pants make a great unexpected silhouette. The proportions are classic, sporty, and clean. Add pearls and mules or a canvas tote and lug-sole shoes.

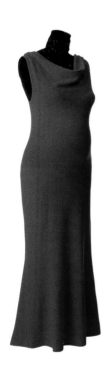 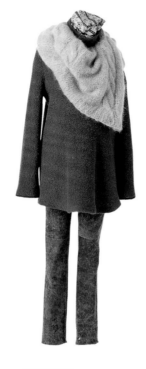 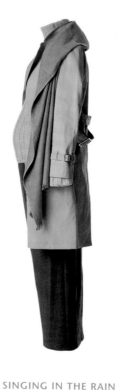 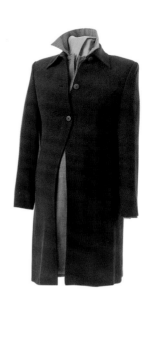

WRINKLE-FREE
EVENINGS If you
can take only one
dress with you on your
travels, make it this
new wrinkle-free knit
cowl-necked evening
gown. The next day you
can wear it underneath
a cable-knit sweater
and over boots as
a skirt.

WEEKEND IN THE
COUNTRY This hand-
knit mohair sweater can
be worn alone or as a
layering piece. Suede
jeans are a wonderful
extravagance, but
practical from day to
night. This can also
work as a city look with
dark boots.

SINGING IN THE RAIN
A waterproof raincoat
sees you through
heavy weather. Pair
it with an elastic waist
wool/cotton skirt.
The pashmina scarf
doubles as an evening
wrap. Everything
pictured is layerable
and lightweight.
The outfit works post-
pregnancy as well.

TAILORED TOPPER
The three-quarter
length is perfect over
trousers, skirts, or
dresses, and the
lightweight fabric
prepares you for any
climate. Add color
accents with a spirited
blouse, or change the
look with oversized
jewelry. It takes you
from tea at the Ritz to
the conference table.

zone of comfort

Comfort cues will greatly improve your travel experience. From essential oils and bottled water to your favorite pair of fuzzy slippers, do not forget to bring things that will take the strain out of your travel experience.

A neck roll in black cashmere and an eye pillow in black satin are well-appointed luxuries that will make you forget you are sitting in coach.

LAUREN'S STORY

"I traveled a lot while I was pregnant. I usually wore an ankle-length wool jersey knit dress with a T-shirt underneath, and my cocoon coat that doubled as a blanket. I wore high heels all the time. When I got off the plane, I would put on my driving moccasins. I also shipped all my luggage. I carried the lightest pocketbook in the world and kept a spray bottle to hydrate my skin. For the first time in my life, I started buying paperback books. It was about being as minimal and light as possible. You want to plan ahead for comfort. Less is more.

"Anytime I was in a public space, I was freezing. Commuting on a train in the summer, it was ninety degrees outside, but sixty degrees inside. When you are pregnant, remember that your inner body temperature is wildly unpredictable. Some women carry shawls, others carry portable fans. I was always cold, so I learned to carry a little cashmere shawl. I used that as a pillow. Remember, even if you are traveling with other people, you will still be responsible for lugging your things around. I had a great leather tote that I used to carry around, but it weighed two pounds without anything in it, so I looked for the same shape in canvas."

Foldable satin slippers come in their own satin bag.

THE BEST SHIP-THROUGH SUITCASES:

- Zero Halliburton

- Tumi: Black, ballistic, fabulously lightweight.

- Samsonite: The global leader in luggage.

THE BEST CARRY-ON BAG WITH WHEELS:

- Takashimaya nylon pull: Super lightweight and portable.

GREAT PAIRS OF SHOES:

- Sneakers: Pull-on Adidas, Y3 by Yohji Yamamoto, Nike iD, and Prada Sport bring sneaker comfort with a lot of style.

- Shoes with lug soles for no slipping! Tod's driving moccasin. Match with a great pair of ankle socks.

- Sturdy pumps: Everybody makes one, from YSL to Nine West. Classic, comfy, and elegant.

THE BEST TRAVELING ACCESSORIES:

- The smallest umbrella you can find: From the Getty to the MOMA, art museum gift shops have the best umbrellas.

- A "crusher" bucket hat: Can be had from J. Crew, Banana Republic, or Burberry.

- A light handbag: Hervé Chapelier, Kate Spade, and Longchamp light nylon bags won't weigh you down. They will double as a diaper bag later.

- Portable mister spray: Try any brand from Stelton to Tupperware, fill it with water, and use it when you are hot.

- Neck roll: Find one covered in cashmere or soft cotton.

- Black fold-up slippers: To really make the plane ride comfortable, pad around in these.

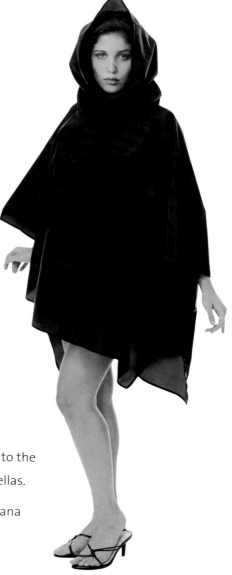

Big Things Come in Small Packages: An avant-garde Japanese designer from the pages of French *Vogue*? Look again. From the epicenter of modern design, this waterproof nylon poncho folds into a neat 6"x 5" pocket square. Carry it everywhere for sudden rainstorm protection. Poncho from the Museum of Modern Art.

7.

speak softly
and carry a great handbag

Accessories are more important than ever during pregnancy. Fantastic shoes, a great scarf, or a lovely pair of earrings can lift your spirits and make you look and feel like your old stylish self. Invest in great footwear, a sensible coat, and fancy lingerie to keep your look polished and pulled-together. Neatness counts. Scale is important. Keep away from distracting, messy, and cumbersome items. It is far better to have one quality handbag than several cheap ones. Now is also not the ideal time to buy the heaviest Kelly bag in the world. When buying scarves, handbags, and jewelry, look for items that make a bold but simple statement. Do not overaccessorize yourself. On the other hand, it may be the best time to buy that Hermès scarf you have always wanted.

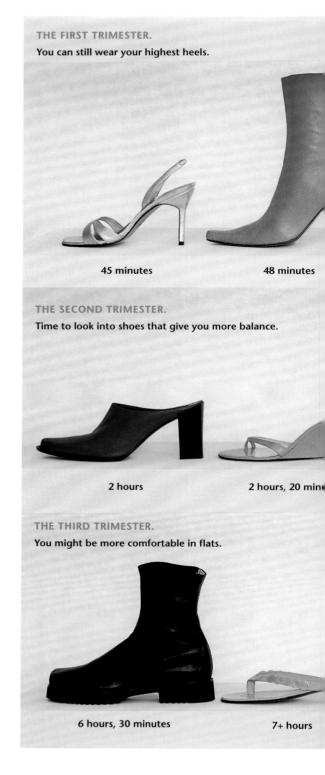

THE FIRST TRIMESTER.
You can still wear your highest heels.

45 minutes 48 minutes

THE SECOND TRIMESTER.
Time to look into shoes that give you more balance.

2 hours 2 hours, 20 min

THE THIRD TRIMESTER.
You might be more comfortable in flats.

6 hours, 30 minutes 7+ hours

fantastic footwear

Now more than ever, your shoes need to not only offer support and comfort but also look great and complete the look.

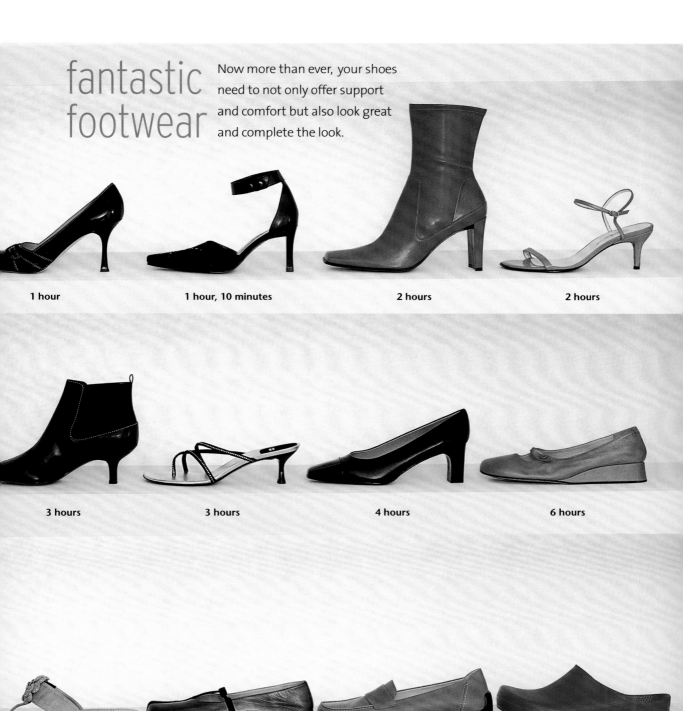

1 hour

1 hour, 10 minutes

2 hours

2 hours

3 hours

3 hours

4 hours

6 hours

7+ hours

all day

all day

all day and all night

doctor, doctor

"Why do pregnant women have problems with their feet? Because they carry more weight around, and their center of gravity is displaced anteriorly [to the front]. The biomechanical problems they experience with their feet is due to the way the foot is functioning. But as a general rule, pregnant women can wear whatever they are comfortable wearing. From a podiatric standpoint, even heels are fine as long as they feel comfortable. In fact, if they have painful flat feet, which a lot of women experience—pain in the arch and the bottom of the heel—they might even feel better in a low heel than a totally flat shoe. But be warned—heels can make pain in the arch and heel go away, but they may aggravate the front of the foot. I do recommend that pregnant women keep off the three-inch stilettos—they could fall and hurt themselves."

—Dr. Paul Greenberg, podiatrist in New York City

on-the-street interviews: HEEL DILEMMAS

"Footwear is a huge problem. I own eighty pairs of shoes. I love shoes. I was a size six shoe and now I am a six and a half, but I cannot buy too many, because I do not even know what size I will end up being."

—Attorney, Cincinnati

"I gave up my high stilettos but I am still wearing three-inch wedges! Yup, still tottering around in those at eight months and looking a little ridiculous."

—Retail executive, Short Hills, New Jersey

"Oh, I am always wearing heels, I just bought them in a bigger size since my feet grew. I bought a few pairs of staple shoes—sling-backs, a pair of black pumps that I love—but I did not go nuts. I figured I will be pregnant again and they will come in handy."

—Entrepreneur, Los Angeles

the great cover-up

Balance the need for protective elements with style by choosing coats with structured tailoring and of good proportions made of light fabrics. Do not invest in a shearling or fur—it can be too cumbersome and may be too heavy to carry. Choose a coat you can wear afterward, like one in a cozy bathrobe-style maxilength. Remember, your internal thermometer varies during pregnancy. You also want something that is weatherproof and will shield you from the rain. Waterproofed, can it go from day to evening, and is it lightweight enough to be a transitional piece?

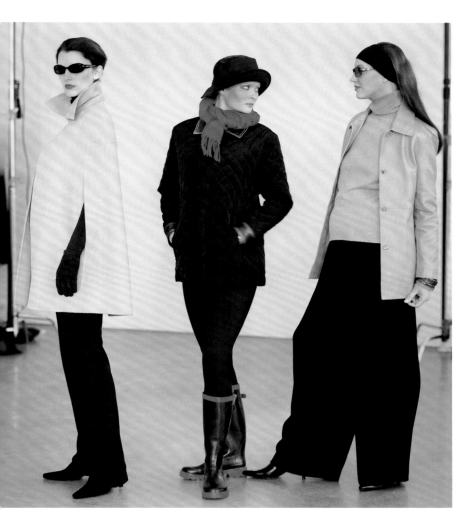

LONG ON MILEAGE, SHORT ON LENGTH
Classic car coats are not just for driving anymore.

LEFT
This camel-hair cashmere cape is the essence of Ali McGraw style. A vintage Norman Norell cape is a demure yet sophisticated option. Not originally made for the expecting mother, but the fit is perfect for maternity.

CENTER
This black nylon barn jacket with leather collar is a worthwhile investment, classic in durability and style. You can stay in fashion without being a slave to trends. You can even wear it post-pregnancy.

RIGHT
A tailored cut-edge leather jacket is a true luxury during pregnancy. You might already have one in your wardrobe. If not, it is sure to be as useful during as afterward. A monochromatic look—camel coat with camel turtleneck—is a refined, interesting, and modern palette.

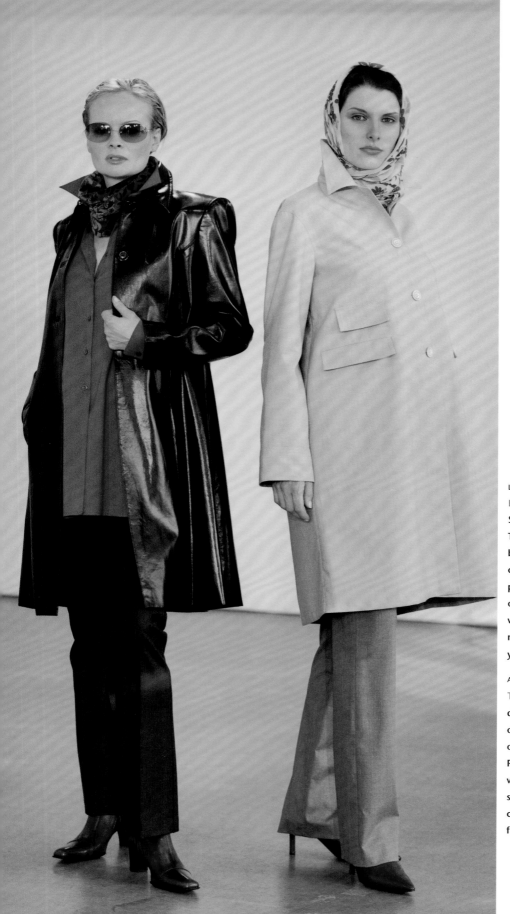

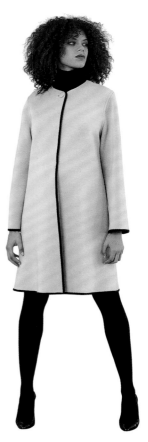

LEFT

BLUSTERY DAY OUTERWEAR

Sleek, waterproof, and durable. Try a rubber topper in chocolate brown (LEFT). This coated-linen cotton raincoat (RIGHT) displays proportions that mimic the styles of 1950s coats worn by the ladies who lunch. Modern, clean, and minimalist. It keeps you warm year-round.

ABOVE

THE PRINCESS DIANA

Bonded, double-face wool-knit, reversible, one-button topper with the ease of a sweater with a touch of the Parisienne. Buy it in ice blue to wear over black. Fun but sensible, this wrinkle-resistant, crunch-resistant coat will be your favorite in the fall months.

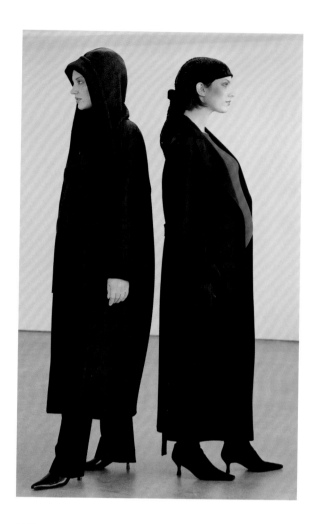

ABOVE

LONG, LUXE, AND LEAN

The hooded cocoon coat (LEFT) is perfect for travel. It can double as a blanket and is fully reversible. Looks great over a plain T-shirt or a structured suit. Roomy enough to cover you and your partner on an airplane.

"I wore this coat everywhere when I was pregnant. Now I use mine as a blanket to throw on the kids on the backseat of the car when I'm not wearing it." —Lauren Sara

A slight adjustment to the traditional reefer coat (RIGHT) makes it perfect for pregnancy. Let the belt hang down to accentuate the long lines. A classic you never feel bad about owning, even when you are back to your old self.

RIGHT

MAXIMUM CHIC The double-breasted classic plaid maxicoat with deep pockets has the feel of real luxury. The subtle swing accommodates and flatters your growing shape.

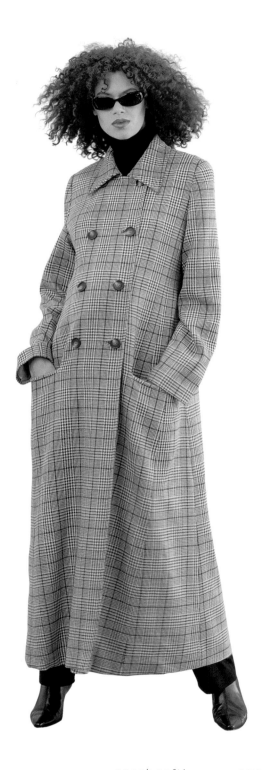

necessary objects

Even if you wear the same black tunic and pants every day, your accessories can change the way you look. Handbags are a great way to showcase your personal style. Choose that bag carefully—it is amazing how much you will rely on the tiniest accessory during the next nine months. Consider investing in a completely new handbag collection, and keep in mind that your shoulder-strap or handbag preference may change because of how your body feels. Just because you need to carry a lightweight bag, your choices are not limited to a nylon tote. There are many alternatives out there. Resist the temptation to buy an oversized bag. Keep your bag neat and small. Oversized accessories can lend a sloppy overall appearance. A woman gives off a very polished look when her bag is the perfect punctuation to a simple outfit. Think classic, and do not ruin the silhouette you have adopted. It is best not to look overwhelmed.

TOP ROW
As varied as each of your moods, having the perfect bag is important. To really make a look current, always have the right bag, from a classic camel tote to an icy satin evening bag.

CENTER ROW
These bags represent only a small slice of the pie. Keep in mind, it's a really important time to look neat and not messy. Structured handbags add a polished look to any outfit.

BOTTOM ROW
Bags can make you look fabulous and on top of your game. This is one area that's not about comfort but all about style and getting it right.

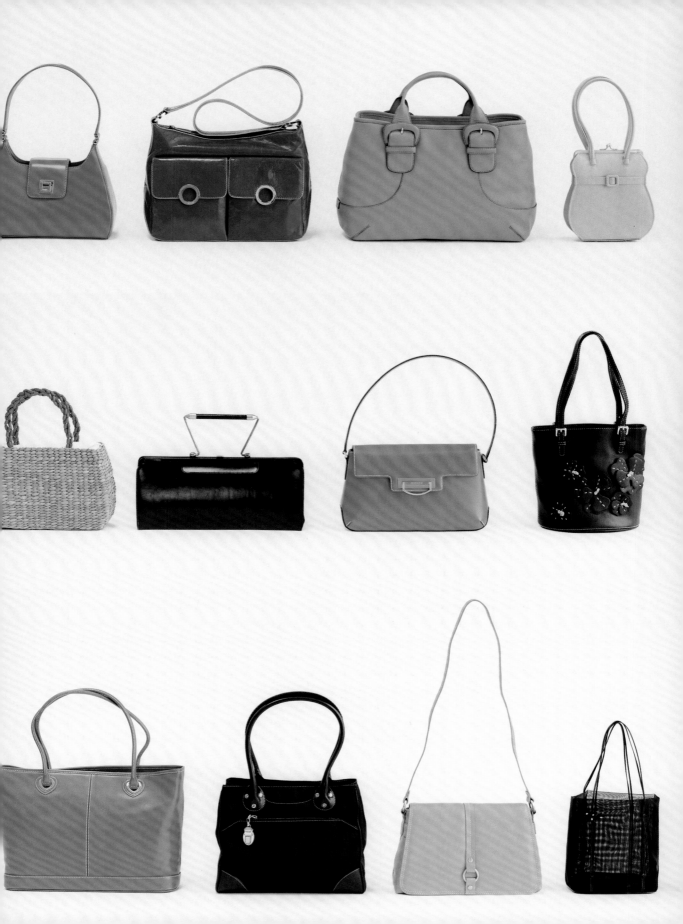

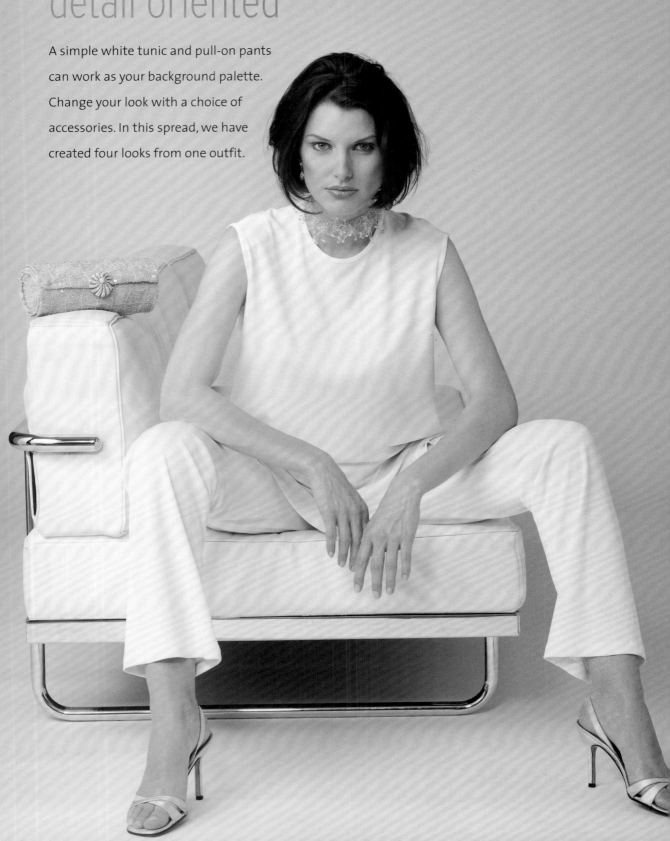

detail oriented

A simple white tunic and pull-on pants
can work as your background palette.
Change your look with a choice of
accessories. In this spread, we have
created four looks from one outfit.

EVENING AFFAIR (OPPOSITE) With a beaded necklace, beaded bag, and open-toe stiletto mules, you are ready for nighttime delights.

LA BOHÈME (RIGHT) Play with your mood by donning turquoise jewelry and carrying a fun Karma bag.

DAY AT THE RACES (BOTTOM LEFT) Are you going to the Kentucky Derby or Hamptons Invitational? Add a striking sun hat, loop an equestrian scarf around a structured handbag, and slip on a pair of wedge heels for the afternoon.

QUADROPHENIA (BOTTOM RIGHT) Adopt a "mod" look with a high-tech watch, sleek leather boots, chunky accessories, and a geometric-print scarf. Do not forget your sunglasses!

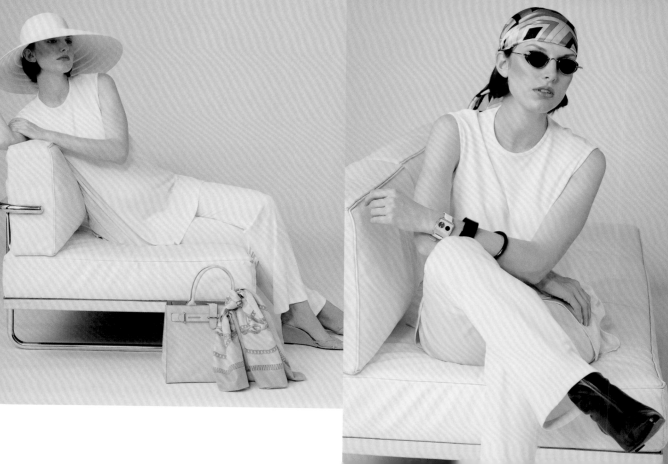

8. beauty basics.
it's all in the details

W hen you are pregnant is the time to concentrate on keeping "the glow." Keep your skin and hair lustrous and indulge in lingerie that makes you feel pampered. Maintaining your makeup and beauty regimens and keeping up with your appearance are important factors during these nine months. Do not let them slide—it will make you feel better if you look like yourself.

PRESENT A FRESH FACE TO THE WORLD (LEFT) Looking well groomed is a necessity. Keep your eyebrows shaped and your hair regularly styled. You might want to try wearing a deeper lipstick to draw attention upward and to your face.

USE A LIGHT HAND (TOP RIGHT) Do not experiment with drastic changes in makeup application. You want to look like yourself, not an exaggeration.

A FINE BLUSH (CENTER RIGHT) Use soft natural-bristle brushes that feel soft and silky against your skin.

STYLING PROCESS (BOTTOM RIGHT) Your hair maintenance regimen does not need to change—most salons offer vegetable dyes that are safe to use on pregnant women.

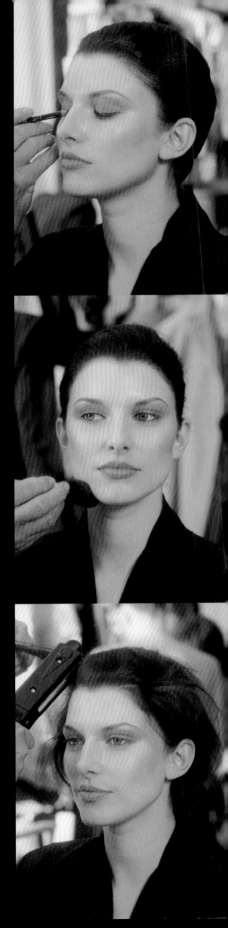

caring for maternity hair
by stephen knoll

The most important thing to remember is that during pregnancy, your face can change. But those changes occur in the later months, not the early ones. So if you feel as though you need to make a change in your hairstyle, do so earlier in your pregnancy, not later. When you are pregnant, your emotions run the gamut. You do not want to go to drastic extremes. The next day or the next week, you might feel completely differently. I advise women not to make any radical changes until after they have delivered.

It is important for women to pay even more attention to their hair during pregnancy because this is a time when you are feeling the least attractive. You are excited and happy, but at the same time you might not feel as great about the way you look when you glance in the mirror. Your hormonal changes can affect your hair. Your hair needs to be reshaped; it is already changing. Your hair continues to change pretty much all the way through until you stop breast-feeding, if you choose to breast-feed.

During your second trimester, hair changes dramatically. Curly hair gets curlier and curlier. It may go back to the way it was before pregnancy, or it may never change. I have seen some wild curls. Those hormones can make temporary or permanent changes to your hair. Typically, hair gets thicker because there is more of it. Usually what happens is hairline loss. The hairline loss comes after the birth of your child. Usually you lose hair at the temples and the two corners of the forehead, sometimes along your entire hairline. There is nothing you can do. This may be the time to make some changes, to add more layers around your face, more bangs.

Usually hair becomes very lush and full during pregnancy and then starts to get very dry after delivery. That is when you see the downside. I advise a conditioning treatment once a week.

A QUICK CUT Schedule your last appointment before delivery three weeks before the baby is due.

For a thinner face, I stay with more layers around your face, to make it softer and more forgiving—as opposed to wearing a very strong or blunt or severe cut. Your face can really change dramatically in the last six weeks. If you get very full in the face, you really lose the sculpture and dimension.

Schedule your last appointment before delivery three weeks before the baby is due. Do the highlights and have it cut and conditioned. That will take you through the next two months, and by that time you can spend a little time away from the baby. You will have adjusted and can come back to get redone.

The best cuts for different types of faces:

- Round. Wear layers that are soft around your face. Or embrace the roundness, and wear very short hair to accentuate your nicely shaped head.

- Oval. You can be very flexible—it depends on your best features. If you have a thick neck, you do not want your hair too short. Work on other aspects that are flattering. With an oval face, you can wear most hairstyles, but look at what you need to enhance or disguise—for example, if your forehead is too large or if you have excess weight on your neck.

- Square. Layers are good to soften the jawline. Wear your hair above the shoulder, but with a lot of layers. Do not make your face longer. You do not want really long hair if you have a long face. Better to have those layers at the cheekbones. That brings more dimension, and more attention to your eyes and cheekbones.

- Heart-Shaped. Blunt haircuts work best.

"Some women freak out when they start to lose their hair after they deliver, but it is very normal. Your hair will grow back even stronger. I never had anyone who lost her hair and never had it grow back. As for keeping your color maintained while you're pregnant, you should consult with your doctor before doing any highlighting or bleaching."

—Laurent D. of the Privé Salon

HAIR PRODUCTS TO CONSIDER

- Volumizer, to lift hair from the roots.

- Deep conditioner, to give hair a shiny, soft, glossy texture.

- Vitamins for your hair.

- Intensive scalp-treatment masks are stocked with vitamins and are great for damaged hair. Hair tends to get very dry when you are pregnant. Every two weeks, leave on a hair mask in a hot towel or wrap.

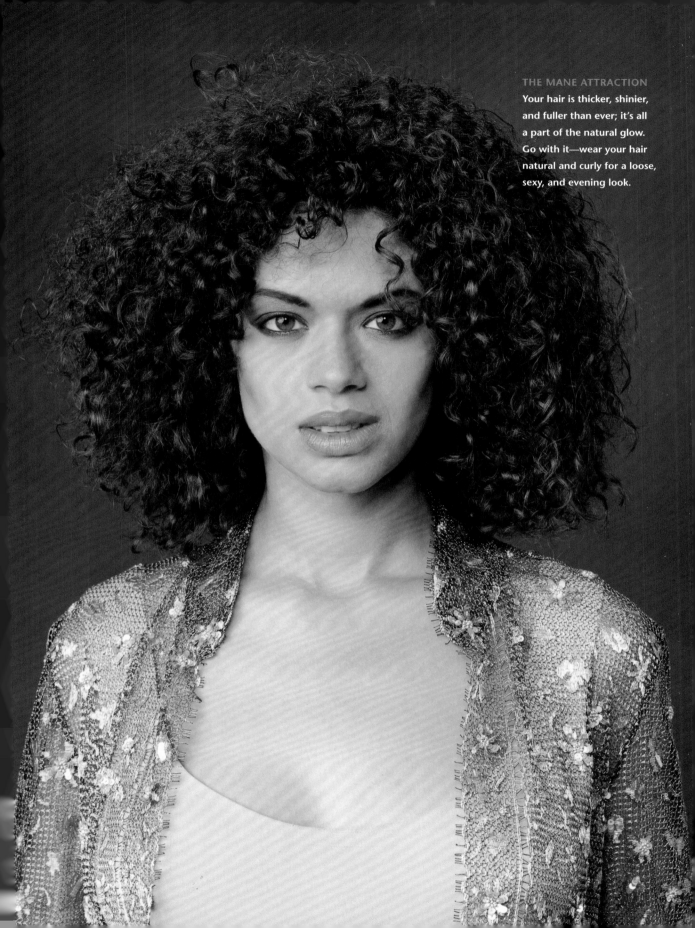

THE MANE ATTRACTION
Your hair is thicker, shinier,
and fuller than ever; it's all
a part of the natural glow.
Go with it—wear your hair
natural and curly for a loose,
sexy, and evening look.

luxurious lingerie

It is not necessary to sacrifice style and sexiness for support and comfort. The right undergarments are very important; do not buy them just as an afterthought. As for panty hose, skip the control top and just buy taller panty hose; the extra height gives you the extra width you need. You do not have to forgo any pleasurable elements. Look for drawstring waists and silk pajamas for a tactile sense of luxury. Since your skin is sensitive, you do not want anything tight. You want to feel sexy and comfortable at the same time. Pamper yourself, as now is the perfect time to get a cashmere bathrobe and sexy leopard slippers. There is an abundance of luxury in this area that you should explore.

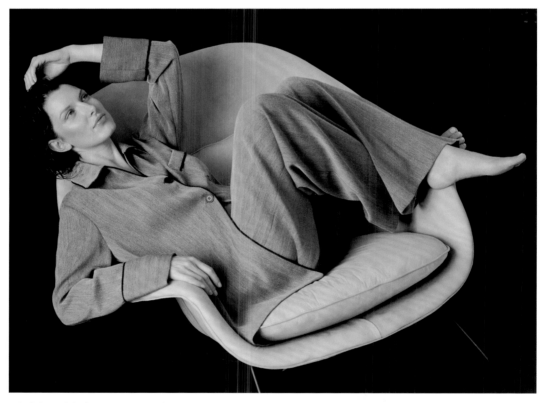

Men's broadcloth pajamas are a fantastic option.

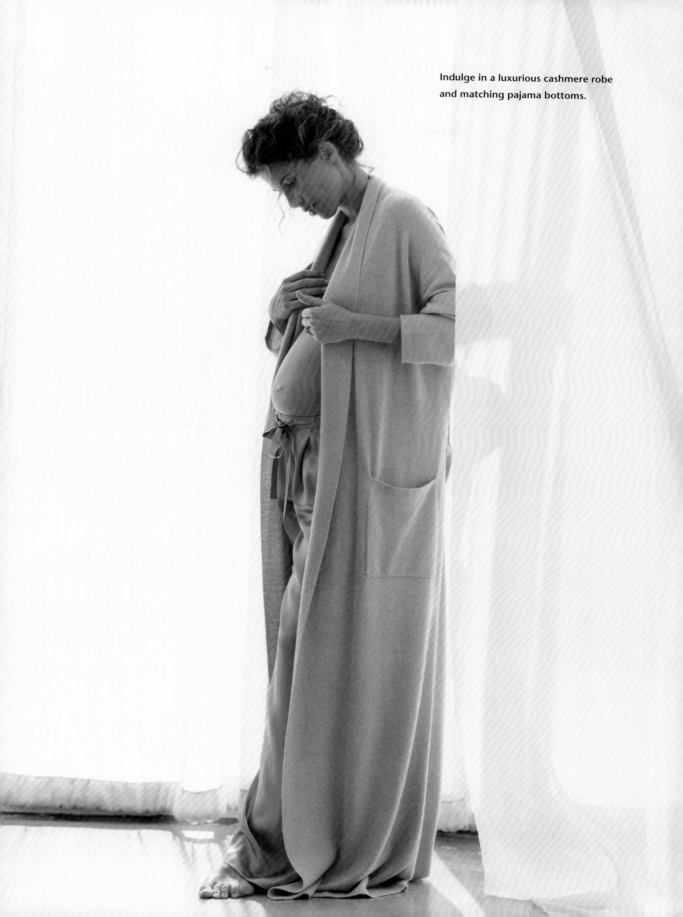

Indulge in a luxurious cashmere robe
and matching pajama bottoms.

baby your body

Like most women, you probably did not give much thought to your beauty regimen prior to pregnancy. But as an expecting mother, you must reconsider what you put on your body. Safety is a top priority. Few products make specific claims of safety during pregnancy. Belli Cosmetics is the first to offer a comprehensive collection of medically sound body-care products for pregnancy and beyond. Below is a list of products you might want to try:

ELASTICITY BELLY OIL Plant extracts prepare your skin to stretch without damage.

BELLI SOOTHERS Flavored in peppermint or lemon to soothe the stomachs of expecting mothers.

PURE COMFORT NURSING CREAM Breast-feeding can result in a loss of moisture, which leaves delicate skin cracked, dry, and sore. This lanolin balm soothes and mends. It is safe for nursing babies.

STRETCHMARK MINIMIZING CREAM For use after childbirth to heal stretch marks.

FOOT RELIEF CREAM Swelling and cramping can cause discomfort in the ankles, feet, and calves. Aloe vera heals and moisturizes the feet.

SKIN SMOOTHING BODY EXFOLIATOR During pregnancy, skin can become taut and dry. Exfoliate regularly to improve circulation, texture, and tone.

ALL-DAY MOISTURE BODY LOTION SPF 15 Pregnancy can cause itchy, tight, dry skin. Moisturize with aloe vera and chamomile to comfort and restore skin's natural pH level.

COMFORT CLEANSING BODY WASH A mild moisturizing wash to help keep skin feeling soft, clean, and comfortable.

ANTI-CHLOASMA FACIAL SUNSCREEN SPF 25 Pregnancy hormones and sun exposure can overstimulate pigments and result in splotchy brown areas. Daily sunscreen is your most effective protection.

personal comfort

Buying a maternity bra is a difficult experience. You want to balance comfort with beauty. Cotton and spandex bras are great for women who do not want the underwire push-up look all the time. Many women have a bra wardrobe—some sexy, wonderful bras; some cotton for all-day comfort. For some women sheerness is an issue. You do not want fabric that is too thin.

Balance comfort and beauty. There is no need to go to the drab extreme.

"I haven't given up my thong underwear! I need them now more than ever. Especially once my clothes became very tight. I just went out and bought larger-sized thongs. I did not want panty lines just because I was growing in all directions. I found some all-cotton thongs that felt great."

—Advertising executive, New York City

HAPPY FEET **Regular pedicures are a form of relaxation.**

eating well
by Lauren Slayton, M.S., R.D.

www.foodtrainers.net

Recently the trend has swung so far back into not gaining excessive weight that some of today's pregnant women are actually running into problems of not gaining enough weight instead of gaining too much. In general, if you are working with a nutritionist, you do not want to constantly check in. Check in before you are pregnant, and when you are just starting to try. Then once you are pregnant, check in every trimester, so your weight gain can be monitored.

THE FIRST TRIMESTER For proper weight gain, you only need 100–200 additional calories. It is almost negligible. Eat a little more during dinner, maybe have an extra yogurt or a glass of low-fat milk—and there it is. Just eat a well-rounded diet. Your fluid needs are important—for a single baby, you want to drink 10 cups or 2½ liters of decaffeinated fluid: seltzer, herbal tea, ginger tea, or something lemony. It alleviates nausea in the first trimester. Your blood volume is increasing, so your water needs are higher. For a twin pregnancy, have eight to ten 16-oz. glasses of water a day. Everything for twins is increased! And it is hard to get enough calories when you are carrying twins.

THE SECOND AND THIRD TRIMESTER Eat 300 more calories than usual.

AFTER DELIVERY Eat 500 more calories than usual for an adequate milk supply. Your caloric needs are highest when you are nursing—even more so than during pregnancy.

"When you are pregnant, you want to stay away from injectables. Avoid your Botox and collagen shots. Pregnant women also usually suffer from acne, but you cannot use any topical oral medicines, as they are not safe for the baby. Instead, I treat patients with chemical peels and microdermabrasion. Dermabrasion is the safest; as a purely physical exfoliant, it uses crystals to unclog the pores. Also, lasers are safe to use during pregnancy. Broken blood vessels and stretch marks can be zapped with a laser. I also use a clear laser light for acne. It kills the bacteria and is noncarcinogenic. It is not a medicine, and it does not get metabolized in the body. Avoid anything that has Retinol, or Retin-A—it has been proven to be unsafe for babies. But alpha-hydroxy products are still safe to use."

—Dr. Paul Jarrod Frank, dermatologist, New York City

FISH FACTS

- Be careful of the fish you eat during pregnancy.

- Avoid entirely: mackerel, king mackerel, swordfish, shark, and tilefish.

- Allowable once or twice a week: salmon, tuna*, sea bass, mahi mahi. Limit yourself to two 12-oz. servings a week.

- Allowed: flounder, sole, shrimp. Eat as much as you want.

*You may eat canned tuna more frequently than fresh tuna.

U.S. Food and Drug Administration

foods to watch

If you can avoid caffeine, do so. If not, try to keep it under two regular cups of coffee a day. Caffeine stays in your system longer when you are pregnant. If you have coffee in the afternoon, it might affect you for eight to ten hours afterward. Be very wary of eating cheese. Avoid feta, blue-veined cheeses like Roquefort as well as soft cheeses like queso blanco and Brie. Look for hard cheddar and Swiss cheeses, preferably low-fat. Always have pasteurized dairy. Avoid nonpasteurized milk, yogurt, and cheese products at all costs. If it is unpasteurized but the label says "aged 60 days," it should be safe.

herbs and plants to avoid

Not all herbs have healthy benefits, especially for the expecting mother. It is best to avoid the following:

- Rhubarb

- Aloe vera (injesting only, not surface application)

- Licorice and licorice root

- Catnip: If you have a cat, let someone else give it catnip.

- Cohosh (a menopausal supplement)

- St. John's wort

- Kava

Look for some of these ingredients in herbal teas: make sure they are not there.

on-the-street interviews: BEAUTY

"I wore a little more blush than I normally would; it helped make my face look less bloated. I found stronger blush helped, as did playing up my eyes."

—Beauty editor, New York City

"I get my hair blown out three times a week. So getting it done was my first priority. I was out of the hospital after twenty-four hours, and I went to the hair salon with my whoopie cushion! But I was so happy with my beautiful hair, even though my breasts were exploding since I had not breast-fed for three hours!"

—Marketing director, New Fort Worth

"I loved carrying facial cloths. When the weather was hot, I used them constantly. I guess it was preparing me to carry wipes. I never packed anything like that before."

—Interior designer, New Orleans

"During pregnancy, I softened my makeup. Not that I ever wore that much. But even my hair, instead of wearing it straight, I let it air-dry curly. Everything was softer, my hair, the fabrics I wore. I liked looking more natural when I was pregnant."

—Personal shopper, Denver

TOP AND RIGHT
Sun-kissed lips and a vibrant eye shadow is a flattering combination on any skin type.

9.
the essential
hospital
kit

The most important day of your life is coming. Are you prepared? This chapter includes a list of essential clothes and other items to make your stay in the hospital as stylish and comfortable as possible while your attention is focused on your brand-new baby. Bring good cream, a nice bathrobe, and slippers. Organization provides a sense of comfort—be prepared. Do what it takes to feel good. Have a pedicure. Shave your legs. Put on makeup.

face spa
hydrate
nt wt 1 oz

face spa
creme
nt wt 1 oz

face spa
tone
nt wt 1.5 oz

When packing your bag, bring your favorite pillow. Do not forget the pillowcase and a label that marks it clearly as yours.
There is nothing better than looking great and feeling completely put-together, especially when you have visitors. It will give you an enormous sense of satisfaction, and it frees you to worry about what is really important: your new baby.

E.1

ADDRESS BOOK

- Laminated phone list of your nearest and dearest

- Vases for flowers

- Lip balm

- Facial cream

- A great bathrobe

- Slippers

- Nightgown

- A favorite pillow

- Colored pillowcases to contrast the white sheets at the hospital

- Massage oil for your hands and feet

- A back massager

- Handkerchiefs

- CDs and CD player

- Photo album

- Small plastic alarm clock

- Candles (although check with your nurse first before lighting!)

Use a variety of massagers to relieve stress. Here, a back massager, a foot massager, and an all-around massager can bring surprising and instant relief.

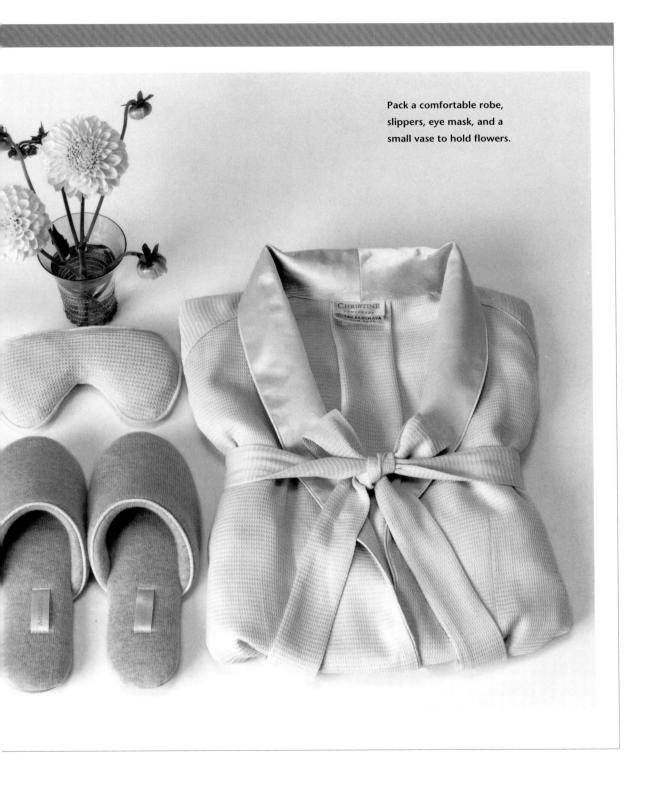

Pack a comfortable robe, slippers, eye mask, and a small vase to hold flowers.

lauren's story

"Personally, being superorganized gave me a sense of calm when the day finally came. On my road to D (Delivery) Day, I thought ahead and planned accordingly. I knew I was going to have a boy, so I bought a gorgeous periwinkle blue bathrobe and the perfect slouchy pajama pants. I felt stylish and clean, and like myself. There is nothing like feeling clean and comfortable, and you cannot do that in ratty pajamas and old bathrobes. Cooing at the baby window, I felt proud of how I looked and felt. The minute I could take off that hospital gown, I did.

"Right before you deliver, you suddenly have so much energy—all this excitement has been building up. I was walking a lot; it became my sole activity. You are as big as a house. It is almost as if you return to the energy you had in the very beginning. It is a weird thing. You think you will not fall into this queer cliché—like the way everyone's wedding dress does not fit her exactly, because she has lost all this weight but on the day of the wedding it fits better. I am a cleanaholic—when I get upset, cleaning makes me feel organized and safe.

"I wanted to have pretty feet, and perfectly hairless legs. I had two pedicures. I thought, What if the baby comes on Tuesday and they are closed on Monday? I wanted to make the best of my looks. I knew I was going to be so exposed, and I wanted to look absolutely exquisite. I have visited friends in the hospital, and they were lounging in their bed in cashmere warm-up suits and their hair was perfectly blown-dried. I had one friend, for example, who only asked for one Tylenol.

"Do not go home wearing your bathrobe, and do not go home in jeans. People are going to be visiting, and you want to look good. You do not want anything that reminds you of maternity. Even if it is just new yoga pants. You do not necessarily need brand-new expensive duds but just set aside one outfit, maybe a T-shirt that is one size down from your pregnancy size, so you feel fresh and good.

"There is a psychological component to material things at this point. You go through an emotional breakdown—Oh my God, I have this baby. The focus is now on the baby, and you think no one will care what you look like, that no one will be looking at you. So it is a little jarring, especially from all the attention you have been getting for nine months. Some women go the total opposite way. Seven days after she gave birth, my sister was wearing a really short yellow miniskirt at the bris. She has fabulous legs!

"A week after giving birth, you will realize you need to buy something to wear to some wonderful event. And you think, What am I going to wear to that? The angst over that outfit! So it is an issue you have to take care of even before the baby comes. Also, now you realize that you are fat, not pregnant. You are out there but you do not want people to notice you. There are people who say, This is it, that their entire life is about having this baby. But you have to think of your life as a continuum; sophisticated people look past to the future, tomorrow and next year.

"I myself was a disaster. I cried. I did not take a shower until three o'clock the next day.

"There is a moment of time when you 'lose' yourself—especially a week before the birth or two weeks after, when no one is making a fuss over you anymore. That is when the crying begins. You are not special anymore. Do not let this happen. You might wake up and look in a mirror and be horrified. Remember to take care of yourself and what you look like— you will feel better if you look better.

"It is also a moment of intense joy. After my son Henry was born, my mother and my sister helped me clean up. They brushed my teeth, fixed my hair. When they left it was eleven at night and I was in a room where I could see all of Philadelphia. And I thought to myself, I have joined that club. I do not know what was going on, but something flew in the window. I thought it was an angel. It really happened. I looked at the skyline and saw an angel. It was transcendent. I was so happy.

"You know, you get very caught up in the physical discomfort, but when I was just alone, on the first day, when they brought him in, I forgot all about that. And my mother, my sister, and I were just cooing over him. We thought, Oh, he is so beautiful! He is doing great! He needed nothing! And the nurse comes in and asked, "Have you changed him? How many diapers have you used?" We thought they were taking care of him—but we realized, Oh no, that is why the diaper was soaking! And he never had a burp! He could have died! We were not idiots; it just never occurred to us.

"The day he came home from the hospital, my twin sister, who is the mother of two children, held him. I have a photo of my sister's hand in the picture, this hand touching him. I saved this picture. The beautiful hands that were touching him. I felt that we were going to be taken care of—there was something special about that. The photo is of the back of our heads, but you can see her hands touching the baby. Also, when I gave birth, I had unbelievable respect for my mother. You begin to think your mother is Wonder Woman dressed as your mother.

"At that moment, I wanted every mother with me. These women have been through more than any man has been through. You feel incredibly guilty about the way you have treated your mother. How incredibly difficult this entire experience is. And in your heart of hearts, you think, This child will never say anything bad about me because I brought him here."

hospital beauty

Keep your hair out of your face. Opt to look clean and free. Lip gloss and moisturizer are key. Though you are not having your hair done, you still want to look presentable. You want to start thinking about the long road back.

Keep your beauty products in Ziploc bags. Do not forget to bring shampoo, conditioner, shower gel, and facial soap.

the hospital wardrobe

During the trip to the hospital, you will be wearing clothes you will likely throw away. Pack "disposable" clothes—Shaker-knit sweaters, sweatshirts, cotton pants. These are the kinds of clothes that can take a spill or a stain. Keep it easy and casual.

your first day in the hospital:

- Get as much sleep as you can.

- Take a shower!

- Opt for soft cottons.

- Prepare an outfit for the baby to go home in.

on-the-street interviews: THE HOSPITAL

"I brought a picture of my first baby to my second delivery. And I brought a present, from the new baby to my older one."

—Mortgage analyst, Miami

"No one told me that you need to take home all of those grandma sanitary napkins they give you at the hospital. Make every nurse bring you those thick sanitary napkins."

—Real estate broker, Greenwich

"My husband still laughs. I packed nightgowns, my makeup kit, hot rollers. I figured there would be time for me to take a shower, pull myself together, and greet people. Well, it did not work out that way. It was a valiant effort on my behalf—to maintain some sense of continuity. The nurses laughed. They came in and pointed to my hot rollers and threw their heads back and roared. They got a good chuckle."

—Interior decorator, New York City

"When I went to the hospital, my husband packed my bag. He packed the skimpiest thongs in the whole entire world! I told him, I cannot wear dental floss!"

—Executive assistant, Minneapolis

"Bring lollipops to the hospital, because you cannot really eat, and they give you all the liquid you need."

—Writer, Boston

Bring pillows in your favorite pillowcases. They will remind you of home. Here, a beautiful European neck roll and square pillow in yellow damask cotton are perfect for the hospital.

the essential hospital kit **163**

10. the new mom

You need to look great and save time at home after your baby is born.

You need key pieces in your wardrobe and should know how to simplify and streamline your approach to getting dressed: what to do within the first week, the first month, and the first year.

Nothing can prepare your heart, home, and aesthetic sensibility for the addition of a new baby. But once things settle down, you can get it together by keeping a sense of humor and a sense of organization. A new baby takes over—no matter what your lifestyle had dictated before. It is best to just give in and not worry too much. At the four A.M. feeding, what does it matter what you wear? Throw a blanket over the couch and stop worrying about what everything looks like. Enjoy the new love of your life.

These Philippe Starck baby bottles come with a built-in rattle.

from three days to three months

After three days, concentrate on getting enough sleep and feeling good. Have your sweats on hand for worry-free comfort. After three weeks, you will be ready to get around more and start to work out again. Then may be time to think about that haircut, highlights, or other beauty treatments you have been putting off.

Rethink your makeup. Try to exercise even if you are heavily sleep-deprived. A good diet and fresh air work wonders. Try to regain control of your neatness and lifestyle. If it is three P.M. and you have still not showered, you may want to get back in your old habits sooner rather than later! After three months, try to pick up the pace at the gym and incorporate the baby into your busy lifestyle. Work the new accessories into your life (the baby backpack, the diaper bag, etc.).

on-the-street interviews: HAVING IT ALL?

"I do not think anybody has it all. I think you do your best—no matter what. For me, you do the best you can, and nothing is perfect. I would rather do more at work. I would rather do more at home. You try to find a good balance, but it is never perfect."

—Account executive, Detroit

"I would not define 'having it all' in just those two categories—career and kids. I am not quite a working mom yet, but I do intend to continue my career while having my family. Hopefully the two different parts of my life will complement each other."

—Bond trader, San Francisco

"I was working in an office where women did not come back to work from maternity leave, so when I was pregnant, I was a little nervous what people would think. I did not want people to see me as a 'pregnant' person. But it turned out well, and I did come back from maternity leave. I guess you could say I 'have it all,' but it just feels like life to me."

—Attorney, Boston

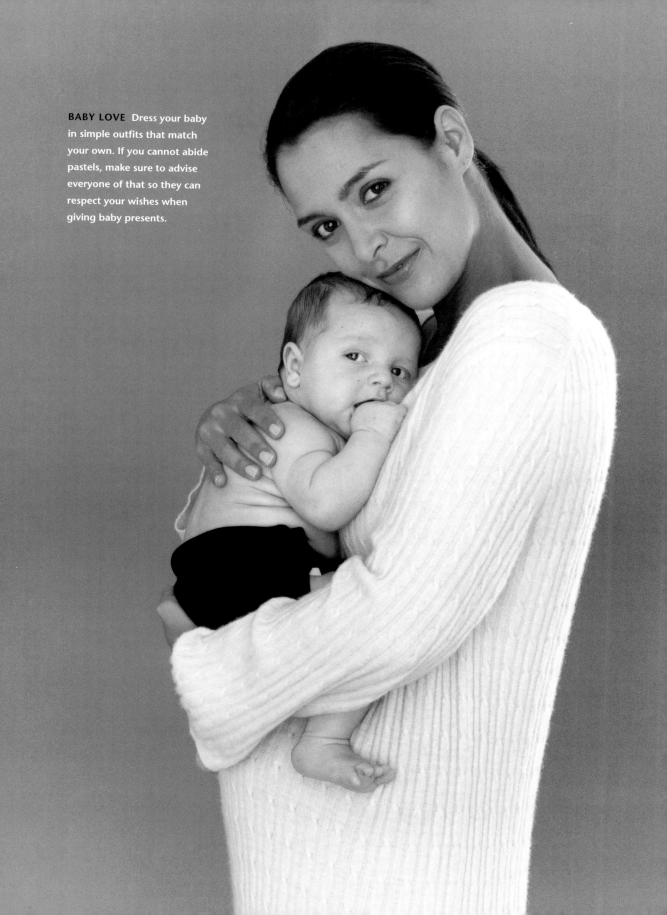

BABY LOVE Dress your baby in simple outfits that match your own. If you cannot abide pastels, make sure to advise everyone of that so they can respect your wishes when giving baby presents.

"My mother worked and had three children, so I had a good example to follow. It was really difficult to go back to work after having a child, but I manage. I love to work and I love my baby, so I try my best to do both."

—Management consultant, Chicago

"I swore I would not let having a baby change our life. My husband is an architect and we live in a minimal, all-white apartment. But now that we have a baby, everything is covered in brightly colored plastic. I promised I wouldn't do it, but it's actually good for the baby to look at colors—it's very stimulating and good for development. We've learned to adjust."

—Interior designer, New York City

THE BEST BACKPACK (FAR LEFT) Choose a diaper bag with masculine edges. A gray, black, or brown backpack can double as a diaper bag and will match more of your wardrobe than a floral-patterned one.

FATHER AND CHILD (LEFT) The two most important people in your life. Do not neglect one for the other. Remember to keep your husband happy as well as your baby. Share the tasks, and let Dad be involved in the baby's life.

PAPOOSE POWER (OPPOSITE) Baby carriers come in all shapes, sizes, and fabrics. Try a European plush carrier—luxury and comfort in one bundle of joy.

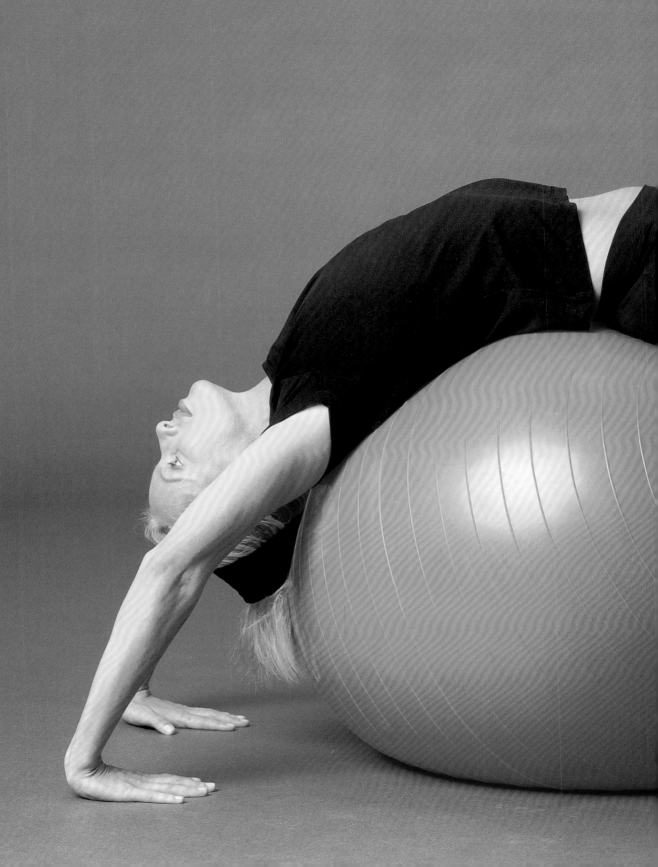

when to exercise

Six weeks postpartum is the right time to start exercising and to begin to lose weight. Look for exercise classes that you can do with your baby. Strollercise, purchase a baby jogger, or buy a video. Also, to make life easier, look into grocery delivery and other ways to give you more time to get yourself back while taking care of a new baby.

The exercise ball is your new best friend. Try it six weeks after delivery.

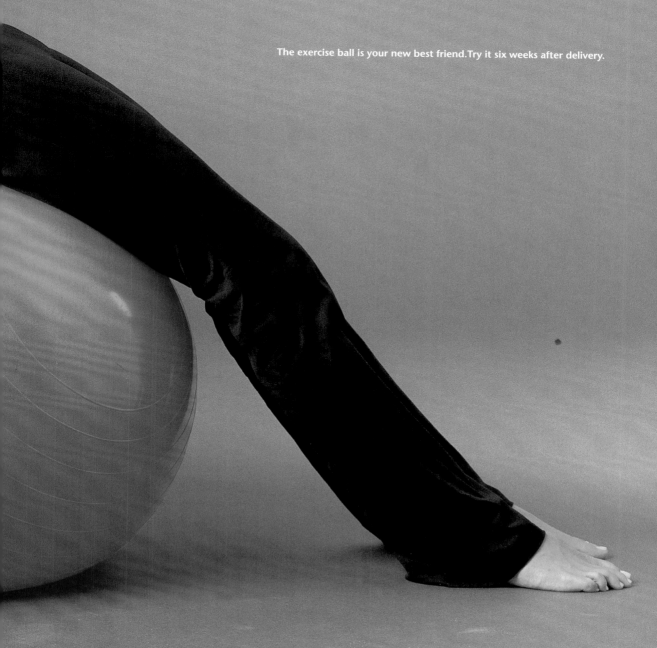

Afterword

I hope you found yourself in these pages and I
hope you establish a good-sense wardrobe that
can help you during these nine exciting months.
I wish you all the best. Remember: there's
nothing cooler than being a chic mom.

Index